FORTUNY

FORTUNY

Anne-Marie Deschodt

Doretta Davanzo Poli

Harry N. Abrams, Inc., Publishers

Contents

THE MAGICIAN OF VENICE
Anne-Marie Deschodt
8

Youth
17

Palazzo Pesaro-Orfei
29

Fortuny, Photographer
42

Interior Decoration, Textiles,
and Fashion Design
63

Fortuny and the Theater
123

TEXTILES AND CLOTHES
Doretta Davanzo Poli
137

The Textiles
144

The Dresses
171

Notes
182

Chronology
184

Bibliography
185

Index
186

THE MAGICIAN OF VENICE

Anne-Marie Deschodt

A boy stood in the embrasure of a high Moorish window, gazing across a southern city as it drowned in the sunset. He saw before him an otherworldly place, a smouldering Orient of the imagination; and as he watched, he heard the rustling sound of a cool fountain in the torrid air, like a snake moving through dry grass.

The arched, Gothic-style window in which Mariano Fortuny stood was set in a high wall of the Alhambra Palace in Granada, Spain. Later in life he was to encounter the mythic Orient again, in Venice, and of all the exotic elements now spread out before him, only the murmur of water from the palace's fountain was later to be repeated in the heavier, greener ripple of Venice's lagoon. As the French novelist Marcel Proust said, Fortuny was guided as if by "the mysterious hand of a genie, leading me through the maze of this oriental city"; and that was the most important thing, for to an artist an ounce of imagination is worth a pound of reality.

Granada was the town of his youth, where the shy and solitary boy was born on May 11, 1871. His father, Mariano Fortuny y Marsal, was a talented Spanish painter born at Reus in the province of Tarragona in 1838. Orphaned as a boy, the elder Fortuny was brought up by his grandfather, an

TOP: the studio of Mariano Fortuny y Marsal on Via Flaminia in Rome, c. 1870.

ABOVE: Mariano Fortuny y Marsal in his Rome studio, 1872.

PAGES 2–3: the main salon of Palazzo Pesaro-Orfei, now the Museo Fortuny, Venice.

PAGE 4: the facade of Palazzo Pesaro-Orfei.

PAGE 6: a self-portrait by Mariano Fortuny y Madrazo stands before one of his silk velvet curtains in Palazzo Pesaro-Orfei.

MARIANO FORTUNY 9

TOP: an arrangement of textiles in Mariano Fortuny y Marsal's Rome studio, c. 1870.

ABOVE: helmets, hats, sandals and other souvenirs of a journey to the East lie on a Renaissance chest.

itinerant carpenter. The two traveled from town to town, making a living as best they could. Whenever he had a moment to himself, the young artist sketched, modeled, or sculpted whatever happened to be before his eyes. They settled in Barcelona in 1850, and his work was so promising that in 1853 he was awarded a four-year scholarship to study at the city's school of fine arts. In 1858 the same public fund sent him to study art in Rome, as the Catalan art student most likely to do the province honor through his painting.

After two years of study in Rome, the young man was abruptly called home to Catalonia. War had broken out between Spain and Morocco and the city of Barcelona commissioned him as a war artist, to sketch and paint scenes of the fighting in North Africa.

Fortuny's commission lasted nearly six months and had a formative impact on his life. The dramatic light and shadow and rich, contrasting colors of Morocco impressed him deeply. He seized every opportunity to escape from his army encampment in search of visual stimulation. Moorish cities, *casbahs*, and scenes of ordinary life interested him far more than troop movements or battles. For the remainder of his short life he had a habit of exploring back alleys, cafés, and bullrings, "por pescar tipos," looking for types.

The elder Fortuny's time in Morocco left him with an abiding love of beautiful objects. He collected trunks full of treasures: furniture, Syrian muskets, damascened scimitars, spiked Saracen helmets, glittering

babooshes, prayer mats, copper trays. He owed the collecting habit to his wartime experience on the staff of the Spanish General Prim, who was famous in Morocco for his princely lifestyle.

When Spain emerged victorious from the conflict, the city of Barcelona commissioned two large commemorative canvases of battle scenes from him. While he was working on them he made a brief visit to Paris to see a monumental battle painting that was much praised at the time: *The Capture of Smalah*, done in 1845 by Horace Vernet. Unfortunately, Vernet's picture so obsessed him that he was unable to finish his own project, which was altogether too similar in theme and size to the Frenchman's. Nevertheless,

in about 1862 he did manage to complete a rendering of the *Battle of Tetuan*, which hangs today in the Museu Nacional d'Art de Catalunya, in Barcelona.

Fortuny y Marsal returned to Rome and set up a studio on Via Flaminia. He filled it to bursting with art objects, and it became a meeting place for artists. His reputation grew rapidly; soon he decided to move to Paris, center of the art world. There, his success was meteoric and he took full advantage of it. He studied with the popular French genre painter Ernest Meissonnier, who taught him discipline and how to tighten his drawing technique. Meissonnier also gave him a lasting interest in lithography and etching, in which he excelled. The critic Théophile Gautier wrote of him: "As an etcher, he is at least as good as Goya, and not far short of Rembrandt himself."

Indirectly, Fortuny y Marsal owed his marriage to Paris, although he married a Spaniard. He was part of a circle of Spanish painters resident in the French city, including Martín Rico, Eduardo Zamacois, and Raimundo de Madrazo, whose father, Frederigo, was an eminent history painter and portraitist as well as director of the Museo del Prado in Madrid. Mariano Fortuny y Marsal visited Madrazo's family in Spain, where he met and fell in love with his friend's sister Cecilia. The couple were married in 1867.

The Madrazos were an aristocratic, austere, conservative family, who served king, church, and art with equal fervor. Cecilia de Madrazo, sister

ABOVE: Mariano Fortuny y Marsal, second from left, with his brothers-in-law Ricardo and Raimundo de Madrazo.

LEFT: Mariano Fortuny y Marsal in the garden of his Rome studio, c. 1870.

and daughter of painters, was well prepared to become the wife and mother of an artist.

In 1872 Fortuny y Marsal took his wife back to Rome, where his career continued to prosper. Painting and engraving were not enough to satisfy his creative energy; before long he was engrossed in gold and silver work, making sword and dagger hilts and handles in the tradition of the great Italian and Spanish metalwork masters. He was offered honorary membership in the French Academy and directorship of the Spanish Academy.

His daughter, Maria Luisa, was born in 1868; his son, Mariano, three years later. In 1874 Fortuny y Marsal and his family passed the summer and autumn at Portici, near Naples. The artist spent six months of calm, creative happiness there and returned to Rome with a completed series of studies, but these were destined never to be turned into paintings. He fell ill in November 1875, and was dead of malaria within weeks, at the age of thirty-six.

As an artist, the elder Fortuny struggled with the desire to pursue his own most deeply felt ideas, rather than the subjects his public craved and acclaimed—a character trait his son, Mariano Fortuny y Madrazo, was to inherit. At Portici in his last months of life he had written: "Today I have no more debts. Only now do I feel able

to begin doing what I feel like doing, and what pleases me." This contrasts strongly with a note jotted down just days before his death: "Here I am once more in the Eternal City: gloom, boredom, no urge to paint: my head is quite empty, like a nest without a bird. I expect they've all flown back to Portici, where I spent the summer so happily."

The younger Mariano Fortuny,

ABOVE: Fortuny's mother, Cecilia de Madrazo, and his sister, Maria Luisa, photographed by the artist at Palazzo Martinengo at the end of the nineteenth century. Maria Luisa loved God, the arts, and animals, in that order; consequently the palazzo was a haven for pigeons, cats, and rats, each species fed in a separate room.

RIGHT: Cecilia photographed by her son at Palazzo Martinengo.

though born in Rome, retained fond childhood memories of visits to Granada. His longing for places far distant in time and space was fed by his father's exotic collections, and especially by the paintings and engravings. The father's subject matter often reflected his dreams and the prevailing taste for exotic scenes: a Moor sleeping beside a stack of beautifully wrought armor, Moroccans playing with a vulture, snake charmers, Orientalist fantasias. All these images are keys to the personality of his more famous child, Mariano Fortuny y Madrazo, Spanish by blood, Venetian by inclination.

The widowed Cecilia Fortuny left Rome for Paris with her two young children. But they stayed there only a short time, for the young woman's heart was set on Venice. Before long she had settled there permanently, while preserving a close connection with Paris, where her brother Raimundo lived. The two were very close and he was to contribute a great deal to the upbringing of her fatherless offspring, especially taking charge of his nephew's education.

By 1889 Cecilia had established a household in the austere Palazzo Martinengo, on the Grand Canal near San Gregorio. Palazzo Martinengo is a plain building dating to the eighteenth century, whose haughty aspect contrasts with the graceful Byzantine houses that surround it. Its facade is clad in a dull grayish stone that makes it seem all the more forbidding. With his father not long dead, the young Mariano now found himself in the care of his pale, serious mother, dwelling in this sober, gloomy palace. Like her husband, she had a passion for collecting beautiful things, but she concentrated on fabrics, especially those of the lavish fifteenth and sixteenth centuries, when adornment reached a pitch of magnificence that has never been equaled since, before the Reformation dimmed the taste for such luxuries.

One of the drawing rooms in Palazzo Pesaro-Orfei, photographed by Fortuny.

The French poet and novelist Henri de Régnier devoted three pages of his lush book, *L'Altana, ou la vie vénitienne* (*The Balcony, or Venetian Life*) to describing the odd atmosphere of cool hospitality and devotion to art that prevailed in Palazzo Martinengo:

Can it be the beautiful, richly ornamented star hung by Gentile Bellini over the marble loggia that frames his portrait of Sultan Muhammad II, with its slender columns and elegant arches—can it be

MARIANO FORTUNY 13

TOP: Mariano Fortuny's mother.

ABOVE: Maria Luisa.

RIGHT: self-portrait photograph by Mariano Fortuny.

this star that, like the magic carpet in the fairy tale, has brought us to the door of an ancient palace, whose gray facade, reflected in the waters of the Grand Canal, displays no trace of the Moorish or Byzantine ornament otherwise so prevalent in strange, graceful, Gothic Venice? Palazzo Martinengo at San Gregorio may date from the eighteenth century, but its foursquare outline has more strength than grace. With its low, theatrical shape, the house looks empty and uninhabited, despite the gondola of its owner moored in front. Nevertheless, when we knock, the door opens.

Madame Fortuny, who has lived in this solemn building for many years, kindly shows us the admirable collection of old textiles she has assembled. Madame Fortuny is the sister of the portrait painter Madrazo, widow of the famous Spanish painter Fortuny, and mother of Mariano Fortuny, who is himself a talented, multifaceted artist, a vigorous young man with regular features and a thick black beard. He has applied his singularly inventive skills to several kinds of technological research.

A true Venetian, he loves his city with a passion and has a profound knowledge of its art. Like the Renaissance masters, he has not confined himself to the practice of one discipline alone; he works in a wide range of artistic fields. Among other things, he has carried out a number of original experiments with lighting and has rediscovered the old methods of dyeing and printing fabrics once used by Venetian decorators. He has created beautiful fabrics for clothing and upholstery in this tradition that are as fine as any crafted here in the past. It is he, Mariano Fortuny, who now offers to show us the collections of Palazzo Fortuny; close familiarity with them has inspired many of his own creations, albeit adapted to modern tastes and uses. With his robust physique, Fortuny himself seems born to wear one of the beautiful, leaf-

patterned brocade tunics with which Veronese clothed the figures in his Weddings, Banquets, and Triumphs.

We now enter the main gallery of the palace, a cavernous room with a ceiling supported by heavy beams. On the walls hang a profusion of brilliant drawings by Fortuny père, along with many interesting studies by his son, Mariano, who now introduces us to his mother. Madame Fortuny receives us with perfect dignity and poise. She and her daughter lead the quietest of lives in Venice, hardly ever leaving their palace. Do they even go down to the inner courtyard that I noticed on my way in, where pigeons coo on the

damp and glistening tiles? Yet despite its cloistered atmosphere, Palazzo Fortuny is a hospitable house, and guests there are regaled with succulent Valencian dishes and elaborate pastries.

Madame Fortuny is assisted by her daughter. These two Venetian ladies have retained a thoroughly Spanish air; their elegant hands are equally skilled in the nice handling of a rosary or a fan, and I can already imagine them touching the marvelous fabrics they have promised to show me as devotedly as they caress the magnificent Moorish casket in carved ivory, which, placed on a table, seems under its rough hinges to contain who knows what secret philters and books of magic spells.

And indeed, we are about to witness a scene of authentic magic in this old, silent palace, whose ghosts seem somehow exorcized by the bells ringing in the nearby Church of the Salute. Madame Fortuny has been fascinated by old fabrics for as long as she can remember, and for her the merest scrap of cloth spared by time is enough to conjure up the splendor of the article of which it was once a part. She made her first fabric purchase in Spain: a blood-red piece of old velvet, embellished with pomegranates. This first foray was followed by many more, and little by little she began to build up a wonderful collection. In Venice, she explains, people tend to part with such things during the winter season. Often, an old lady will appear at the door of the palace and from under her shawl produce a precious family relic, yet another fragment of cloth that bears witness to the vanished luxury of Venice's past.

Mother and daughter open a massive chest in the corner of the room. Here, lightly folded, lie hundreds of fabrics, which they slowly and carefully draw out to show me. The first appears: a fine piece of dark blue velvet made in the fifteenth century, goffered with stylish arabesques. The shade is strange: muffled, deep, and pure, like the color of night.

Slowly, slowly, the magic is wrought: one by one, the fabrics are brought forth, unfolded, viewed, and cast over the back of an armchair or a sofa, later to be replaced in the great cassone *where they reside. There are heavy velvets from Venice, Genoa, and the East, sumptuous and delicate, brightly colored or muted, with rich designs of leaves and figures: velvets once worn by doges and caliphs. There are rich brocades, subtle silks, church vestments, court finery, charming taffetas and glimmering satins sprinkled with tiny florets and bouquets. These were the fabrics used to make the clothes of ladies and gentlemen in the eighteenth century.*

Cecilia and Maria Luisa on the balcony of Palazzo Martinengo at the close of the nineteenth century.

MARIANO FORTUNY 15

Then come garments of every color and composition, some still showing the shapes of the people who once wore them, other fabrics in bolts and lengths, with not a few reduced to tatters. It all happens in a rustle of invisible wings, as the piles of cloth accumulate around the great room, as evening draws in and Madame Fortuny bends over her seemingly inexhaustible trove. In the hush of her palace, she is like the stately conductor of an orchestra, directing a mysterious concerto of precious fabrics in the Venetian twilight.

This was the atmosphere in which Mariano Fortuny grew to manhood. Widowhood redoubled Madame Fortuny's love and admiration for her husband and led her, naturally enough, to raise her son in the cult of his memory. She was not so much his mother as his companion and creative guide. She believed in propriety, modesty, and hard work, and in keeping the rest of the world at arm's length. Her daughter-in-law, Henriette, was to take the same role later on.

Among the close friends of the Fortuny family were a number of artists from Spain: the composer Isaac Albeniz, the poet José-Maria de Heredia, and the photographer José-Maria Sert. But artists of many nationalities and disciplines were drawn to Venice, and thence to the artistic circle that formed at Palazzo Martinengo.

Youth

Mariano's childhood and adolescence were spent between Venice and Paris. He went to school in the latter city and cut his artistic teeth there, painting his first pictures at the age of seven. His first painting master was Benjamin Constant, a specialist in Orientalism; one of his best-known works is a large painting called *The Moroccan Prisoners*, now in the Musée des Beaux Arts in Bordeaux. Later, Mariano worked under the supervision of his uncle Raimundo. As he grew up he moved in a circle of Belle Epoque Parisian artists; among his companions were Alfred Tissot, who at the time was growing interested in religious painting; Paul Baudry, who painted frescoes in two of Paris's great public buildings, the Palais Garnier Opera and the Court of Appeals; the sculptor Emmanuel Frémiet, whose little golden figure of Joan of Arc still shakes her lance at the Quai Voltaire from the other side of the Tuileries; Giovanni Boldini, Alfred Stevens, Jean-Léon Gérôme, and Ernest Meissonnier. It was in Paris that Fortuny began to study not only fine arts, but the technological subjects (photography, electrical engineering, printing methods, and machinery design) that were later to lead to his numerous inventions.

Nevertheless it was in Venice that Fortuny found his true home. After his schooling and until the turn of the century he lived and worked at Palazzo Martinengo, where the love of art and devotion to his father's memory were guiding influences on his life.

ABOVE: the wall of the studio in Palazzo Pesaro-Orfei, where Mariano painted.

OPPOSITE: a series of paintings and drawings by Mariano Fortuny hanging against panels of fabrics in his studio at Palazzo Pesaro-Orfei.

OPPOSITE: on the easel in the salon, a painted copy by Fortuny of the figure of Cleopatra from Giambattista Tiepolo's *Banquet of Cleopatra*. A Saracen Shield Fortuny lamp hangs from the beamed ceiling.

Five etchings by Fortuny:

ABOVE LEFT: *Siegfried Gathering Poisonous Mushrooms.*

ABOVE RIGHT: *The Valkyrie.*

CENTER: *Chestnut Stump.*

BELOW LEFT: *Satin Shoe.*

BELOW RIGHT: *A Venetian Woman, Shawl Blowing in the Wind.*

OVERLEAF: paintings by Mariano Fortuny hang against layers of wall fabrics.

Paradoxically, the habit instilled by this milieu of looking to the past for inspiration led to some of his most daring inventions. Technology fascinated him and he studied the latest innovations in architecture, engineering, and the like with great interest. But although he lived in an age of great artistic experiment he had no faith in contemporary art—"None of it will survive," he used to say. Pablo Picasso, Paul Gauguin, and Constantin Brancusi might as well not have existed, for all the interest he took in them. Perhaps, had his father lived longer, the son's interest in painting might have developed further and he might have been more intrigued by the work of his contemporaries; but this is pure conjecture.

The political issues of the day affected him even less than the artistic questions. These were the years of the Dreyfus Affair, the Boer War, and the Boxer Rebellion; Lenin and Trotsky were transforming Russia and shaking the world; the financial scandals surrounding the building of the Panama Canal were rocking France. Yet none of these events touched him in his seclusion; Fortuny had chosen Venice as his place of refuge, and Venice was the loveliest, the most moving, and the most moribund city in the world.

He lived for ten years with his mother and sister in Palazzo Martinengo, mulling over the past and convinced that modern civilization could not compare to its glories. During this time he established his art studio. In his work he set out to explore this sense of the lost past, to bring his disenchantment to a kind of

OPPOSITE: two oil paintings on wood panel by Fortuny.

TOP: Mariano Fortuny, *Nude*, oil on canvas.

ABOVE: Mariano Fortuny, *Sleeping Woman*, oil on canvas.

ABOVE: Mariano Fortuny, *The Drawing Room and Studio at Palazzo Pesaro-Orfei*, oil on wood.

ABOVE RIGHT: an 1899 poster advertising butter by Fortuny, based on a photograph of Princess von Hohenlohe.

LEFT: Mariano Fortuny, *Self-Portrait*, 1940.

RIGHT: Mariano Fortuny, *Cat and Rio*, etching.

FAR RIGHT: the inner courtyard of Palazzo Pesaro-Orfei.

OVERLEAF: the main drawing room and studio at Palazzo Pesaro-Orfei, with paintings by Fortuny; the one on the right is titled *Tristan and Isolde*.

aesthetic perfection. Disenchantment is a delicious attitude, but luckily its siren call did not wholly captivate Fortuny, for although he considered the past more alluring than the present, more beautiful still was the opportunity to serve the former and bring it to life. Early on he began to organize his life around this notion, applying the technical innovations that so entranced him to the service of a revival of antiquity.

Palazzo Pesaro-Orfei

In 1900 Fortuny moved out of Palazzo Martinengo, changing his address with the new century, as if he had waited for the date to declare his independence. It was reasonable enough: he was turning thirty and the change was hardly dramatic, since he remained in Venice. He merely crossed the Grand Canal and set up his studio in one room of the thirteenth-century Palazzo Pesaro-Orfei, which today is known as Palazzo Fortuny, and is home to a museum dedicated to his work.

The palace was not one of the splendid, imposing edifices of the Grand Canal. It was in a quiet corner, ancient and atmospheric, with a small, graceful courtyard and high pointed Gothic windows made of tiny circular panes of glass. It was very dilapidated and a great effort of imagination was needed to conjure up the splendors of the Renaissance and Baroque centuries, when lavish balls had been held there. The Orfei Musical Society had occupied the premises

ABOVE: one of Fortuny's silk-voile lamps. The pattern is an Italian-influenced arabesque print and the shape resembles a turn-of-the-century reticule.

RIGHT AND ABOVE RIGHT: details of a work table with an adjustable lamp, designed by Fortuny.

OPPOSITE: Fortuny built this immense work ladder, seven meters (23 feet) tall, with a platform on top. The three-tiered lamp is called a Saturno.

Fortuny's lamps ranged from the exotic and decorative to the practical. Above is a standing lamp with a weighted base and a silk-voile polyhedron shade, hung with *pâte-de-verre* beads on fine strings; the printed pattern reproduces Persian and Coptic motifs.

between 1786 and 1826, and had done considerable damage. Later, local craftsmen had gradually taken over the building, so that by the time Fortuny moved in some 350 people were working there. He began to acquire additional rooms in the building, one by one, restoring them as he went along. He knocked down partitions and removed additions until the exterior and interior once more resembled their original form, and he was the sole occupant.

Thus he made Palazzo Pesaro-Orfei his own. He did not wish only to restore the structure to its medieval appearance; he wished to fill the rooms with objects and images that would conjure up a sense of distant ages. Over the years he had become a painter of great technical skill, and had explored a wide range of other art media. He now set up workshops for fabric printing, etching, photography, carpentry, and painting. These were virtual laboratories for experiment and invention. He was especially fascinated by the humble props and details on which artistic expression depends.

In 1897, in Paris, he had met Henriette Negrin, a Frenchwoman who was to become his companion and later his wife. In 1902 she joined him in Venice and became in every sense his partner. She was omnipresent in all his projects at Palazzo Pesaro-Orfei. As he began to develop his experiments with dyed and printed fabrics, she took charge of many aspects of production. In particular she was expert in dyes and tints and controlled the nuances of coloration in the manufacture of

ABOVE: a studio lamp in painted metal with a wheeled base and an adjustable, directional shade.

OPPOSITE: two versions of a tiered work table with an adjustable lamp. The one at far right is on wheels.

LEFT: detail of the polyhedron lampshade.

RIGHT: a tasseled silk-voile lamp shaped like an inverted Oriental hat, with a stylized floral pattern.

BELOW: detail of an adjustable studio lamp that can be raised or lowered on a rod. The vertical bulb stands within a cotton umbrella reflector, white inside and black outside.

OPPOSITE: a silk-voile hanging lampshade in the form of an embossed shield, printed with Arab decorative motifs and trimmed with beads

OVERLEAF: a desk lamp with a chrome shade and plain wooden base stands on a folding wooden table also designed by Fortuny.

fabrics. Fortuny's techniques for manipulating dyes were one of his signature processes and a great trade secret; Henriette took many of them with her to the grave.

Fortuny and his wife entertained often, with a mixture of natural simplicity and luxury peculiarly their own. Often they decorated their gigantic salon-studio with panels of rich fabric, lending it a character at once warm and mysterious. Sometimes their parties had a theme: one was called a palette party, in which a color was assigned to each guest. The story goes that one luckless man, for whom Fortuny had no great liking, was asked to dress in yellow, the artist's least favorite shade.

At Palazzo Pesaro-Orfei the Fortunys filled their rooms with exotic pictures, carpets, draperies, embroideries, furniture, lamps, and precious objects from many cultures. The effect was of time arrested, of a golden age—several golden ages—recaptured in sumptuous decorations. Visitors were captivated,

drawn away from ordinary reality and into a world of luxurious fantasy. The sense of waking dream was reinforced by that most Venetian of effects, the perpetual presence of flickering water and glittering reflected light; that liquid quality which is so palpable in the lustrous bronze air of the city, filtered through tinted window panes. Fortuny drew for inspiration upon this rarefied atmosphere; the designs for his textiles and other objects echoed the patterns and ornamentation of his exotic collections.

Fortuny himself seldom went out, except to La Fenice, the opera house of Venice, when a work by Richard Wagner was being performed. He considered Wagner the greatest of artists, comparable to Michelangelo, "in whom painting, sculpture, and architecture attained their highest form of expression." Fortuny shared with Wagner a sense that opera was not merely a drama in which poetry was subordinated to music, but a perfect synthesis of all the fine arts together—poetry, music, decorative painting, prose, ballet, and pantomime. Opera spoke to the human imagination, the eyes and ears, with such sensitivity and power that the spectator was overwhelmed. For Fortuny, it satisfied a profound yearning for physical and intellectual beauty.

Fortuny had always been interested in stage design and set decoration, but his passion for Wagner spurred him to further research and several inventions in the realm of theater. He designed theater sets and lighting, movable stages and other theatrical furniture. He made no distinction between craft, artisanship, and high art, so that for him the design of a lamp or a textile was the equal of a painting. To his way of thinking there was no such thing as a minor genre or a task too humble.

He was a prey to the same excitement whether he was working on an etching, mixing his own dyes and inks, perfecting a new type of photographic paper, or painting in oils.

PAGE 35: Fortuny's three-tiered Saturno lamp, with a printed gauze shade in three colors, seen from below.

OPPOSITE: the library; in the foreground are sketches of motifs for stencils; near the windows is a hand press.

RIGHT: an adjustable easel on wheels, another Fortuny design.

BELOW: a portable, collapsible easel with an adjustable seat.

OVERLEAF: three views of Fortuny's library in Palazzo Pesaro-Orfei.

OPPOSITE: an untitled nude study photographed by Fortuny in 1900.

BELOW: *Laughing Nude*, photographed by Fortuny c. 1900.

I had never seen Fortuny's photographs before. They are quite extraordinary. The sensuality of his nudes and the beauty of the women he photographed is the first thing that strikes me. In many of his fashion pictures you can see the outline of the body under the dress, as if it were meant to reveal rather than cover it. And the lighting is superb. . . . One nude is especially remarkable in the way she offers her body to the onlooker, laughing, not with a seducer's laugh, but frankly and straightforwardly—and it is this which makes the photograph so unexpected and so completely modern. Fortuny used a number of procedures which have long intrigued me—shop window mannequins, panoramic cameras. The discovery of his photographs is an event which is technically fascinating, exciting and rich in visual emotion.

Helmut Newton,
1979

MARIANO FORTUNY 41

LEFT: Mariano Fortuny with his Dubroni camera, c. 1890.

BELOW AND OPPOSITE: Mariano Fortuny's friend Giorgia Clementi, photographed by him at the end of the nineteenth century.

Fortuny, Photographer

Fortuny's hallmark was his multi-faceted approach to work. He sought new and better media, methods, and techniques with great discipline and intensity, even as he strove to capture the beauty and brilliance of antique crafts and artworks. It was no accident that he chose to practice his art in the silence of Venice, nor that within Venice he dwelt in a place suffused with calm, grace, and an archaic nobility. Palazzo Pesaro-Orfei is set back, hidden between a disused canal and a back-street *campo*, or small square. Loving the city as he did, Fortuny consciously chose its least obvious, least spectacular aspects, seeking instead its secret, intimate qualities. Above all, he tried to capture the elusive light of Venice, and to express its magic and mystery.

Venice at the turn of the twentieth century, photographed by Fortuny using a wide-angle lens.

TOP: the Piazzetta San Marco seen from the Basin of the Lagoon; the Doges' Palace is on the right.

ABOVE: the Grand Canal seen from the Punta della Dogana, the old Customs House.

OPPOSITE: six photographs by Fortuny. The first three are views of Venice in 1890; the others were taken in Morocco and Egypt.

MARIANO FORTUNY 45

LEFT, TOP AND CENTER: pantomimes in Palazzo Martinengo and on the terrace.

BOTTOM: a self-portrait.

ABOVE: Henriette Fortuny in 1929.

RIGHT: contrasting light effects: Henriette at the beginning of the twentieth century.

46 MARIANO FORTUNY

48 MARIANO FORTUNY

ABOVE: Cecilia de Madrazo on her deathbed, 1932.

RIGHT: the grand salon-studio in 1900.

OPPOSITE: Henriette and a friend in a Venetian garden, photographed with the light behind them, 1905.

OVERLEAF: the grand salon.

Fortuny seldom drew or photographed the famous, beautiful facades of the great palaces, preferring instead the humble balconies, narrow alleys, small bridges, and high walls with wistaria and roses cascading over crumbling masonry. He delighted in sketching the boats of the market gardeners and fishermen of Venice, and portrayed them often in his paintings, etchings, and photographs.

Despite his absorption in Venetian culture and his fondness for Venetian isolation, Fortuny was not cut off from the rest of Europe. In 1915 he accepted the post of honorary Spanish vice-consul in Venice, an office he held until his death. He was also a member of a committee charged with the preservation of the city's works of art; and because Spain remained neutral during the two world wars he was able to store some of Venice's treasures at Palazzo Pesaro-Orfei for safekeeping during both conflicts.

He did what he could to protect Venice's heritage from harm, yet even during the two great wars he remained largely aloof from the twentieth century. The coming of the Jazz Age,

TOP: Henriette inking a stencil in one of the workshops at Palazzo Pesaro-Orfei, photographed by Mariano Fortuny in 1908.

OPPOSITE: a pourpoint (a type of doublet) worn by Orson Welles in his film *Othello*, made of printed gold-and-silver silk velvet and pleated cotton. The design of the garment was based on an Italian Renaissance pattern.

FAR LEFT: a stencil with the pattern made of synthetic fiber, dating from 1930; prior to World War I copper wire was used to make the pattern.

NEAR LEFT: a design for a printed textile.

LEFT: the surfaces of these ostrich eggs in the library were carved into patterns by Fortuny, using a dentist's drill. The motifs are similar to some of those used in his fabrics.

the crash of 1929, and the rise of Nazi Germany had little effect upon him and scarcely influenced his work, except for their grave financial impact. World War II was for him a time of withdrawal and contemplation; he continued to work as Spanish consul and to design and make furniture, lamps, decorations, and exquisite clothing.

As World War I ended, Fortuny's reputation as an interior decorator and clothing designer soared. In the heady years between the wars the inimitable Fortuny look became synonymous with a certain cachet and glamor. Café society fell in love with his mixture of antique-revival and romance; famous actresses and aesthetes began to wear his clothes and dress their rooms in Fortuny fabrics and Fortuny lamps. In these years he redecorated a residence for Consuelo Vanderbilt in the Roman style; transformed the salons of Marie-Laure de Noailles, a member of France's old aristocracy, and of the Italian actress Dina Galli; and designed the gaming room at the Excelsior Hotel on the Lido, Venice's elegant sea resort.

He became the darling of the upper crust, but his success did not alter him. In photographs he continued to wear the same reserved expression; he went out neither more nor less than before and entertained occasionally, as he had always done. His palace was now mostly given over to his various artistic and commercial endeavors: it contained a series of workshops for printing, pleating, electrical work, couture, and carpentry. He employed dozens of workers to print silks with his stencil patterns, using dyes that Henriette continued to mix herself.

Even as his textile business expanded, he continued to pursue his interest in photography. Today, the Museo Fortuny preserves 11,000 photographic plates in its archives. Always interested in manipulating light effects, Fortuny invented and patented a bromide-based photographic paper that allowed him to obtain high-quality black-and-white tones in his prints. The Zeiss firm tried to acquire the patent for the paper and process, but Fortuny refused to sell, fearing that the idea would be copied without proper compensation

One of the fabric-printing presses in the Giudecca factory.

LEFT: equipment in the Giudecca factory.

BELOW: the hand press in the library of Palazzo Pesaro-Orfei.

to him. Indeed, he took out more than fifty patents (registered in Paris) to protect his inventions from imitators and was often suspicious of the motives of others. Among the most notable are a system for indirect theatrical lighting; an arc lamp that can function in any position; a dimmer switch or rheostat for variable lighting; a curved, collapsible theatrical backdrop or cyclorama, called the Fortuny dome; a method of pleating fabric in "wavy pleats"; a method of polychrome printing on textiles; a transparent curtain for vitrines or bookcases; a system of propulsion for ships that allows them to swim in water like eels; and a hat stand of superior stability (the ordinary sort being liable to fall over), with a broad conical base set in a heavy socle, and a spring lodged in the center to

connect the stand with the base. Fortuny's wide-ranging ambitions all had one thing in common: he was fascinated by the attempt to fuse technical innovation with fine art. His inventiveness drew no distinctions between high art and technical expertise. Late in life, intrigued by Walt Disney, he imagined an animated Valkyrie, executed with a blend of drawing and painting. We can only feel sorry that he never pursued this project.

One creation Fortuny never had to patent was his palace. Even today, it retains its unique atmosphere; the great salon-studio seems a cross between a sacristy and an aquarium, dimly lit by its bottle-bottom windows, and hung with textiles like magic curtains. The French novelist Paul Morand describes Fortuny himself as "like one of those old doges whose velvet robes he wore at [one of] the Persian balls . . . in Paris." One can imagine him at work in his studios, dreaming of Eleonora Duse, Sarah Bernhardt, and Ellen Terry as Chekhov's *Three Sisters*, wearing Fortuny dresses in a Fortuny set, in a theater designed by Fortuny. In the next room Henriette, in a working smock, checks her vats of dye; in a farther room, seamstresses sit pleating, ironing, and laughing among themselves.

When Orson Welles was filming *Othello* in Venice 1949, he paid a visit to Fortuny in the hope of finding suitable costumes. The interview was not at first a success. Fortuny was old and frail (he died a few months later) and at first paid scant attention to Welles, despite the director's energy and enthusiasm. Yet when asked about costumes, he roused himself a little. Excusing himself for a moment, he returned with an armful of clothes. From among these he selected a gray-green jacket lined in gray fur spotted with white.

Welles tried on the jacket in front of a looking glass and found himself transformed into a figure from a painting by Carpaccio. This was the effect he sought. In particular the fur seemed to exemplify the Renaissance. When he asked where it came from, Fortuny explained that these were the skins of Australian cannibal moles. The source, he chuckled, was a wonderful fur farm that had solved the problem of feeding its stock "at no cost whatsoever!" Fortuny contributed a number of pourpoints and other period garments to the film.

OPPOSITE: a long-sleeved doublet trimmed with fur, used in Orson Welles's *Othello*, is made of silk velvet dyed with cochineal and printed in gold with pomegranate motifs. It was inspired by a fifteenth-century Italian textile.

TOP: a self-portrait of Mariano Fortuny in costume, early 1900s.

CENTER: a silk-velvet waisted jacket, printed with Turkish patterns in the fashion of the eighteenth century, was also used in Orson Welles's *Othello*.

BOTTOM: a short coat of velvet, printed with a pomegranate motif, that once belonged to the opera star Enrico Caruso.

BELOW: Vittore Carpaccio, *The Arrival of the English Ambassadors* (detail), 1495–1500. Gallerie dell'Accademia, Venice.

OPPOSITE: detail of a dress in pleated silk and gold-printed cochineal-dyed silk velvet, based on a medieval design from Lucca.

We were eating granita di caffè, *crushed coffee ice, with Mariano Fortuny, son of the Spanish Meissonnier, who has become a Venetian by adoption. . . . Looking like one of those doges whose velvet robes he wore at the Persian balls that caused such a stir in Paris, Mariano Fortuny came out of his studio and invited us to his mother's house. She lives opposite the miniature palazzo Réjan is renting. Mme Fortuny offered us dainties to eat that were worthy of Parmigianino; her table, which was covered in point-de-Venise lace, looked like a luscious fruit stall, with peaches on beaten copper dishes and furbelows of gilded and beribboned sweetmeats sprinkled with powdered sugar, whose Venetian name I have forgotten. Proust came here eight years ago; he knew Fortuny; later, he gave many of this artist's dresses to* The Captive, *and now they are part and parcel of the Proustian legend.*

Paul Morand, Venises, *1971*

LEFT: Mariano Fortuny, *Detail of "The Arrival of the English Ambassadors,"* after Carpaccio.

OVERLEAF: dusk in Venice, with the Palladian church of San Giorgio Maggiore across the water. The short silk-velvet cape catches the breeze of the sirocco. It is printed in silver and gold with Coptic designs at the shoulders, Persian tree-of-life palmettes, and cuffs and border motifs inspired by Hellenistic Greek ornamentation.

Interior Decoration, Textiles, and Fashion Design

Richly inventive as Fortuny was, his name will always be remembered principally for two things: his revolutionary design for a bowl-shaped portable theater and his fabrics and dresses. In the opinion of the designer and artist Erté, Fortuny was the only couturier (apart, perhaps, from Mme Grès) whose designs would never go out of fashion.

Fortuny's sense of history and his ability to evoke *fin-de-siècle* decadence and romanticism in his designs made him compellingly attractive to writers. His clothes were frequently worn not only by the divas and *grandes dames* of his day, but by their fictional counterparts. Fortuny gowns turn up in the works of Gabriele d'Annunzio, L. P. Hartley, Mary McCarthy, and Paul Morand, among others, and most strikingly in Marcel Proust's *Remembrance of Things Past*.

Proust must have loved Fortuny's style, for he mentions his robes and dresses more than a dozen times in the novel, and although he never specifies whether they are of printed velvet or pleated silk, he notes their colors with precision. Indeed, Fortuny's clothes link several of the protagonists, who otherwise never meet: Mme de Guermantes, Proust's great portrait of a wealthy member of the French aristocracy, owns many Fortuny gowns; the narrator's young lover, Albertine, longs to possess one.

TOP: a kimono with a print of broad bands.

ABOVE: a *jellaba* of printed cotton taffeta, with Middle Eastern-style decorations on the borders.

OPPOSITE: a printed-velvet cape is tied at the neck with a printed silk-velvet cord.

TOP: a printed kimono worn with a turban, photographed by Fortuny.

ABOVE: a medieval-style dress of printed silk gauze, worn with a Venetian cape.

MARIANO FORTUNY

A long burnous of black silk velvet printed in gold in fifteenth- and sixteenth-century Tuscan motifs. The autochrome photograph, an early form of color print, is by Fortuny.

It is the painter Elstir, a key character, who first introduces them to her. At one point she explains to the narrator that she must leave because "in eight days she had an appointment to try on Fortuny's latest models"—an appointment she would sooner die than miss. He refuses to believe her, but in turn admires the dresses worn by Mme de Guermantes, a great arbiter of feminine style. When Albertine finally abandons her lover, she takes a Fortuny cloak with her. Proust usually invented pseudonyms for his characters and other references; it is a mark of his admiration for Fortuny that he uses the designer's real name.

Fabrics are ephemeral works of art, compared to architecture, statues, paintings, and the written word. Beautiful garments lend only a fleeting glamor to the bodies they clothe. Fortuny's fabrics were invested with all the magic and elusive beauty of the *grand siècle* to which his mother had belonged; these qualities were, perhaps, the thing that most attracted Proust.

Fortuny and Proust knew each other; Fortuny's uncle Raimundo was married to the sister of a close friend of the novelist. Nevertheless, for the most part they corresponded only occasionally, although they shared a strong interest in sixteenth-century Venice. Proust was fascinated by Fortuny, who like himself was a recluse and a perfectionist, unmoved by fads and passionate about detail. According to the Fortuny scholar Guillermo de Osma, in 1916 Proust wrote to Maria de Madrazo, asking for

precise information about Fortuny's designs: "Do you know whether Fortuny has ever used as a decoration for his dressing gowns those pairs of birds . . . which appear so frequently in St. Marks on Byzantine capitals? And do you know if in Venice there are any paintings (I would like some titles) in which any mantles or dresses appear that Fortuny may have (or could have) gained inspiration from?" His aunt confirmed that there were such birds in the dresses, and Proust therefore wrote of Albertine's dress that it "was covered with Arabic ornamentation, like the Venetian palaces hidden like sultan's wives behind a screen of pierced stone, like the bindings in the Ambrosian Library, like the columns from which the oriental birds that symbolized alternatively life and death were repeated in the shimmering fabric."

In 1919, encouraged by the end of the war and by the warm reception of the *haute monde*, Fortuny founded a publicly held joint-stock company, the Società Anonima Fortuny. He opened his first commercial factory, a silk-printing plant, on the Giudecca island of Venice. The printing and pleating workshops there were supervised by Henriette; Fortuny himself was constantly traveling in search of new contacts and new business. Soon after the company began production he exhibited its textiles at the influential trade fair of Paris, the Exposition Universelle des Arts Décoratifs. Viewers went into ecstasies over the work—the perfection of the silks, their jewellike colors, and the sheer splendor of the patterns.

A long burnous of gold-printed gray silk velvet uses fifteenth- and sixteenth-century Tuscan motifs. The autochrome is by Fortuny.

OVERLEAF: a long burnous of emerald-green velvet, printed with fifteenth- and sixteenth-century Tuscan pomegranate motifs in gold and lined in brown velvet, is photographed in the water gate of a Venetian palace.

Various capes and mantels worn over a Delphos dress:

TOP: a printed silk-gauze jacket with pagoda sleeves, edged with *pâte-de-verre* beads, is a typical model for 1915.

ABOVE: a short cape for indoor wear is made of threaded silk gauze printed in a lace pattern and edged with *pâte-de-verre* beads.

TOP: a silk-velvet cape with geometric patterns is worn short and belted in front, with a flared train.

ABOVE: a batwing tunic of silk gauze, edged with iridescent *pâte-de-verre* beads, has a Spanish–Moorish motif.

MARIANO FORTUNY

ABOVE: a large shawl of printed silk gauze, edged with *pâte-de-verre* beads, is shown with a matching dress.

RIGHT: a Venetian bolero of threaded silk voile in a lace-pattern print with *pâte-de-verre* bead trim is worn over a matching attached taffeta and a medieval-style dress.

OPPOSITE: a detail of bolero showing the *pâte-de-verre* beads.

Albertine listened with passionate interest to these details of costume, these visions of elegance that Elstir described to us....
"I should love to see Venice." "You may, perhaps, before long," Elstir informed her, "be able to gaze at the marvellous stuffs which they used to wear. One used only to be able to see them in the works of the Venetian painters, or very rarely among the treasures of old churches, or now and then when a specimen turned up in the sale-room. But I hear that a Venetian artist, called Fortuny, has rediscovered the secret of the craft, and that in a few years' time women will be able to parade around, and better still to sit at home, in brocades as sumptuous as those that Venice adorned for her patrician daughters with patterns brought from the Orient."

Marcel Proust,
Within a Budding Grove
(In Search of Lost Time), *1919*

OPPOSITE: a Fortuny medieval-style dress in lace-printed silk gauze over plain velvet, photographed at Palazzo Barbaro, Venice.

BELOW: Fortuny displayed a collection of his dresses in the workshop at Palazzo Pesaro-Orfei.

I felt a slight gnawing at my heart. On the back of one of the Compagni della Calza identifiable from the emblem, embroidered in gold and pearls on their sleeves or their collars, of the merry confraternity to which they were affiliated, I had just recognised the cloak which Albertine had put on to come with me to Versailles in an open carriage on the evening when I so little suspected that scarcely fifteen hours separated me from the moment of her departure from my house. Always ready for anything, when I had asked her to come out with me on that melancholy evening which she was to describe in her last letter as "doubly crepuscular in that dusk was falling and we were about to part," she had flung over her shoulders a Fortuny cloak which she had taken away with her next day and which I had never thought of since. It was from this Carpaccio picture that that inspired son of Venice had taken it, it was from the shoulders of this Compagno della 'Calza that he had removed it in order to drape it over the shoulders of so many Parisian women who were certainly unaware, as I had been until then, that the model for it existed in a group of noblemen in the foreground of the Patriarch of Grado in a room in the Accademia in Venice. I had recognised it down to the last detail, and, that cloak having restored to me as I looked at it the eyes and the heart of him who had set out that evening with Albertine for Versailles, I was overcome for a few moments by a vague feeling of desire and melancholy.

Marcel Proust,
The Fugitive
(In Search of Lost Time), *1925*

ABOVE: a gold-printed velvet coat with an Italian Renaissance motif.

ABOVE RIGHT: a display of printed-velvet robes, some with Qufic script motifs on a background of arabesques, others trimmed with fur, like the robes of Venetian Doges.

RIGHT: a long robe of lined silk velvet, printed with Qufic script overlaying arabesques on the lining, the broad collar, and the cuffs.

OPPOSITE: a gold-printed velvet cape with an open back, embellished with lotus, palmette, and tree-of-life motifs.

PAGES 74 AND 75: details of a short coat with pagoda sleeves in blue velvet printed with silver floral, palmette, lotus, and tree-of-life motifs, with matching sash and buttons.

PAGE 76: an indigo-dyed velvet, printed with Spanish–Moorish designs, photographed in Palazzo Barbaro. In the right background, barely perceptible, is a desk once used by Henry James.

PAGE 77: a silk-gauze housecoat with *pâte-de-verre* beads, worn over a Delphos in a room at Palazzo Barbaro.

Connoisseurs were able to trace Fortuny's textile designs to their fifteenth- and sixteenth-century sources; other visitors to his first exhibitions merely admired their exceptional quality. After the Paris Exposition Universelle, Fortuny, the Venetian Spaniard, was said to be making the most beautiful fabrics in the world.

The public's reception of the Paris exhibition was so encouraging that Fortuny decided to open a retail shop there. The first Fortuny shop was at no. 62 rue Pierre Charron, off the Champs-Elysées. It sold dresses based on designs borrowed from the Renaissance and Byzantium, from the Arabs, Persians, Copts, and Indians, and from the golden age of Flanders and ancient Greece. Among these, there were designed coats, tunics, cloaks, burnouses, togas, and caftans, all of them inspired, like his fabrics, by antique originals.

The success of the Paris shop was almost overwhelming. Rather than try to maintain it, Fortuny transferred his collections to Mlle Babani, the dealer who sold Liberty of London in Paris, and a shop at 98 boulevard Haussmann. Mlle Babani was a very modern merchant, as skilled in publicity as she was in retailing; the result was that soon such stellar ladies of the stage as Isadora Duncan, Eleonora Duse, Sarah Bernhardt, and the sisters Emma and Irma Gramatica began wearing Fortuny's Delphos dresses, on stage and off. So too did the famous hostess known as La Casati. The clothes Fortuny designed for stage use were distinguished by special research into their "dramatic and

OPPOSITE: a silk-taffeta Delphos printed in three colors is worn as it should be, next to the bare skin. Beneath the material the body appears fluid and supple, caressed by the material.

LEFT: one of the many labels designed by Mariano Fortuny; the words are woven on a ground of gold faille.

BELOW: three printed-velvet caftans stand on dressmaker's dummies in Fortuny's workshop.

MARIANO FORTUNY 79

OPPOSITE: a short black velvet coat with raglan sleeves, trimmed with a border of sixteenth-century Turkish arabesques, is worn over a black Delphos.

LEFT: a coat printed in gold with a Renaissance arabesque pattern imitating brocade is worn with a silk-velvet shawl and a Delphos.

BELOW: a silk-velvet burnous-cape, printed with gold thread, with square plackets for the buttons.

artistic effects"; they were made so that the actress's slightest movement caused them to ripple around the body with an almost supernatural grace. These magnificent garments were embellished with iridescent glass beads and buckles, manufactured for him in Murano; he selected the colors and shapes personally.

The poet and novelist Gabriele d'Annunzio described La Casati, who figures as the elegant heroine of his 1910 book *Forse che si, forse che no* (*Maybe Yes, Maybe No*), wearing Fortuny:

She had wrapped herself in one of those very long shawls of Oriental gauze that the dyer-alchemist Mariano Fortuny colors by plunging it into his vats of mysterious chemicals, mixed with a wooden ladle,

sometimes by a sylph, sometimes by a gnome. When it emerges it is tinted with strange dreams, and he then imprints on it whole new generations of stars, plants, and animals.

In 1929 Fortuny opened a couture shop in New York, and soon had representatives in London, Poland, and Madrid, as well. His prices were stratospheric. In his obsessive quest for perfection he ordered natural red brazilwood pigment sent from Brazil and indigo from India; straw was imported from Brittany by the wagonload to create his yellows. Fortuny's carmine was distilled from Mexican cochineal beetles, and rotten eggs were specially imported from China so that their whites could be used as a fixative for silver and gold. The smell of them lingering in the textiles did not escape Proust's fastidious nostrils; but it faded, leaving Fortuny's golds and silvers possessed of an extraordinary brilliance (which may also have been due to a special process of polishing with amber).

Most of the fabrics for interior decoration were dyed, pleated, and printed at the Giudecca factory, but Henriette continued to oversee a small operation at Palazzo Pesaro-Orfei, where lengths of silk or silk velvet for clothes and upholstery were finished. When Fortuny entered the American market he formed a partnership with his friend Giancarlo Stucky, the owner of Palazzo Grassi. At around this time he invented an industrial process for printing on white cotton to reproduce the silky, raised effect of brocade. This involved an immensely complicated technique for printing superimposed colors, but the result was a triumph, and made Fortuny fabric designs available for wall hangings and other household uses. Prosperous American ladies, who were already dressed in Fortuny gowns, soon began covering their walls and furniture with these exquisite fabrics.

ABOVE: the influential experimental dancer Isadora Duncan with her husband, the poet Sergey Yesenin, and their adopted daughter, Irma Duncan. The ladies wear Delphos dresses.

OPPOSITE: a broad printed-silk shawl is wrapped sari-style around a Delphos dress. The shimmering material reflects the light on the waters of the Venetian Lagoon.

MARIANO FORTUNY

ABOVE: a Fortuny autochrome photograph shows a black-velvet dress printed with gold in a pattern inspired by seventeenth-century Brussels lace.

OPPOSITE: a short belted coat of black velvet, printed with gold Renaissance arabesques. The curlicues resemble the rich carvings on the old state gondolas of Venice.

PAGE 86: a creamy velvet cape is printed with silver.

PAGE 87: a long velvet cape is printed with a gold leaf pattern inspired by Chinese and Japanese textiles. Its warm tones harmonize perfectly with the pink-and-beige brickwork of a Venetian alleyway. In the distance across the water lies the island of the Giudecca, with the Palladian church of the Redentore.

PAGES 88 AND 89: these ocher-and-black silk overblouses, printed in silver with foliate motifs at the borders, were usually worn over a matching Delphos.

PAGES 90 AND 91: a transparent printed-voile batwing dress with borders of intertwined Qufic script and flower patterns against a background of arabesques.

LEFT: an Espanola printed-velvet cape with patterns and accessories inspired by Spanish folk art.

OPPOSITE: a cotton taffeta *jellaba* has the shimmering look of shantung silk. It is printed in gold on a vivid cochineal-dyed ground in imitation of traditional Central American patterns.

Of all the outdoor and indoor gowns that Mme de Guermantes wore, those which seemed most to respond to a specific intention, to be endowed with a special significance, were the garments made by Fortuny from old Venetian models. Is it their historical character, or is it rather that each one of them is unique, that gives them so special a significance that the pose of the woman who is wearing one while she waits for you to appear or while she talks to you assumes an exceptional importance, as though the costume had been the fruit of a long deliberation and your conversation was somehow detached from everyday life like a scene in a novel? In the novels of Balzac, we see his heroines put on this or that dress on purpose when they are expecting some particular visitor. The dresses of to-day have less character, always excepting the creations of Fortuny.

Marcel Proust,
The Captive
(In Search of Lost Time), *1923*

OPPOSITE: a Delphos dress with long sleeves is a poem in pleats and *pâte-de-verre* beading.

LEFT: this sculpture of Nefertiti in the Musée du Louvre, Paris, was an inspiration to Fortuny, as was the *Charioteer* of Delphi.

BELOW: Natasha Rambova wearing a Delphos dress, 1924.

More than his designs, more than his paintings, more than anything else he undertook, it was Fortuny's celebrated undulating pleated silk that enriched him while he lived and perpetuated his fame after his death. This was a process—replicated by the modern Fortuny firm today, but still something of a mystery—in which the finest silk was folded into minuscule and perfectly even pleats, to create an effect as of rippling waves.

MARIANO FORTUNY 95

OPPOSITE: extravagant panels of printed voile are worn over a Delphos with a sash and ribbons, in the style of ancient Greece, as reinterpreted on the classical French stage.

LEFT: the silent screen star Lillian Gish in a Delphos dress, c. 1920.

BELOW: a flower-printed silk shawl worn over a goffered and pleated Delphos. Such shawls could be tied, worn loose, or cinched with a ribbon like an eighteenth-century shepherdess's dress.

OPPOSITE: a friend of Fortuny's photographed in the salon-studio, wearing a printed Delphos dress. On the wall above her is a painting by Fortuny's father of Mariano and Maria Luisa as children in the family's Japanese salon in Rome.

LEFT: Selma Schubert in 1907, wearing an orange Delphos. This early color photograph was taken by her brother, Alfred Stieglitz.

OVERLEAF: a drawer full of original Fortuny silks in the collection of Liselotte Höhs. These Delphoses in all the colors of the rainbow are tumbled together like so many heavy pre-Raphaelite braids or like long, delicate flowers. Unraveled, they gently expand; despite their butterfly-wing fragility, they can still be worn.

PAGE 102: a detail of the trailing skirt of a silk taffeta Delphos reveals that it is printed on both sides. The thin silk allows the inside colors to show through.

PAGE 103: the same dress has flared sleeves like fluttering fans, Art Nouveau vases, or morning-glory blossoms.

The Fortuny gown which Albertine was wearing that evening seemed to me the tempting phantom of that invisible Venice. It was covered with Arab ornamentation, like the Venetian palaces hidden like sultan's wives behind a screen of pierced stone, like the bindings in the Ambrosian Library, like the columns from which the oriental birds that symbolized alternatively life and death were repeated in the shimmering fabric, of an intense blue which, as my eyes drew nearer, turned into a malleable gold, by those same transmutations which, before an advancing gondola, change into gleaming metal the azure of the Grand Canal. And the sleeves were lined with a cherry pink which is so peculiarly Venetian that it is called Tiepolo pink.

Marcel Proust,
The Captive
(In Search of Lost Time), *1923*

For the clothes worn by Greek women in the golden age of their art, we may refer to Attic funerary stelae of the period. Athenian women all wore the Ionian chiton, a linen tunic made with narrow pleats . . . linen stuffs, because of their stiffness and lightness, are less prone to weight distortion than their equivalents in wool. The result is that they do not drape or fall very naturally. For this reason, the ancients folded their tunic cloths into hundreds of small pleats. They do not seem to have known about irons. Nevertheless, in certain parts of the countryside a traditional technique known as plissage a l'ongle [nail-pleating] is still used, in which peasant women patiently pleat certain parts of their bonnets with their fingernails. The same method is used for the surplices worn by the clergy in church.

So writes Leon Heuzey, first curator of antiquities at the Louvre; it is correct in every detail. The important fashion designer Paul Poiret, Fortuny, and all those who followed in their footsteps found a way to replicate traditional methods that had never been meant to be secret.

The famous pleated silk taffeta Fortuny dress called the Delphos was invented early in the century, based directly on the robe worn by the bronze Hellenic Greek statue called the *Charioteer* of Delphi, which Henriette Fortuny loved. In the years just before World War I women were becoming more liberated and were freeing themselves from corsets and rigidly constructed dresses. The dancer Isadora Duncan made the liberation of women's dress a cause. In this climate, the Delphos dress was a runaway success.

LEFT: a Delphos with a long, uneven upper hem, in the English edition of *Vogue*, 1927.

BELOW: Liselotte Höhs in a Delphos dress with a short top with an uneven hem.

BELOW LEFT: Mme Condé Nast wearing a Delphos with a broad printed-cotton belt, c. 1909.

OPPOSITE: a silk-taffeta Delphos printed in three colors and on both sides lies on the patterned terrazzo floor of a Venetian palace.

In the matter of dress, what appealed to her most at this time was everything made by Fortuny. These Fortuny gowns ... were those of which Elstir, when he told us about the magnificent garments of the women of Carpaccio's and Titian's day, had prophesied the imminent return, rising from their ashes, as magnificent as of old, for everything must return in time. ...

Like the theatrical designs of Sert, Bakst and Benoist, who at that moment were recreating in the Russian ballet the most cherished periods of art with the aid of works of art impregnated with their spirit and yet original, these Fortuny gowns, faithfully antique but markedly original, brought before the eye like a stage decor, and with an even greater evocative power since the decor was left to the imagination, that Venice saturated with oriental splendour where they would have been worn and of which they constituted, even more than a relic in the shrine of St. Mark, evocative as they were of the sunlight and the surrounding turbans, the fragmented, mysterious and complementary colour.

Marcel Proust, The Captive
(In Search of Lost Time), *1923*

LEFT: this pleated silk-taffeta sheath with short arum-lily sleeves and a printed cotton belt was the original and most famous Delphos, so named by Henriette Fortuny in honor of the *Charioteer* of Delphi.

OPPOSITE: a black Delphos is accented with lines of tiny gold *pâte-de-verre* beads running round the arms and down the flanks to the ankle.

ABOVE: a silk-gauze batwing tunic was made to be worn with a Delphos. It has a border printed in flowery Qufic script against a background of arabesques and festoons of iridescent *pâte-de-verre* beads.

MARIANO FORTUNY 107

Lakey, with her clear intellect, cut through their indecision. Kay would like to be buried in a new dress, of course. The others could not imagine shopping for a dead person, but Lakey took one of Kay's dresses for a sample and went straight off to Fortuny's and bought her an off-white silk pleated gown—the kind the Duchess of Guermantes used to receive in. Then the others remembered that Kay had always longed for a Fortuny gown, which she never in her wildest moments could have afforded. Kay would have loved the dress and loved having Lakey buy it for her.

Mary McCarthy,
The Group, 1954

LEFT: an iridescent Delphos, seen from the back, mermaid-like against a rich background of Renaissance velvet. Note the foaming effect of the hemline.

OPPOSITE: a simple red Delphos, dyed with cochineal.

ABOVE: three silk-taffeta dresses are printed with Liberty-inspired patterns perfectly suited to their Neoclassical cut, typical of the first decade of the century.

OPPOSITE: a train of several silk-voile shawls, one laid over the other, float down from the high guipure-lace collar of an Edwardian dress.

BELOW, LEFT TO RIGHT: a printed-velvet dress with a Liberty pattern; a Delphos worn under a short pleated silk-taffeta tunic, with medieval-style ribbons crossing over the bosom; a pleated silk-taffeta printed sheath with short flared sleeves, belted with a Liberty-inspired *foulard*.

The pleat is the most fragile of all textile constructions. Pleats can rumple or come undone at the least provocation; if they flatten in an irregular way, the whole effect of a dress may be spoiled. Undulating pleats are even more difficult to make and maintain properly. Mariano Fortuny, surveying the problem, sought a method of making such pleats permanent.

He found a solution: a machine that heat-stamped the cloth into permanent undulations and vertical pleats, for which he was granted a patent on June 11, 1910. A month earlier he had patented yet another technique for printing on fabrics, paper, and other suitable surfaces. He was now free to work with any fabric on the planet, just as he chose, without fear of competition. Together with two other patents from June and November 1909 for a "type of undulating pleated fabric," and a "type of women's garment," these patents spawned a veritable industry. From them flowed a fashion that was to seduce the world's most elegant women, fascinate writers, and inspire painters and photographers. It is because of them that the name of Fortuny is still so universally known.

Elegant, cosmopolitan Europe, with its taste for magnificent lamés, brocades, and velvets, printed or stamped with gold and silver, embraced the Fortuny dress. These eye-catching silk pleats clung and floated about a woman's body in a slightly risqué manner and were the talk of the salons. That cultured world was not destined to survive the shock of World War I, but Fortuny's designs did.

Meanwhile, Mariano himself, confident that his business was going well, traveled widely in Europe and North Africa. In Europe, he attended the theater; in Africa he visited weavers' workshops, searching for traditional Berber patterns. He wanted to know about every fabric in the

ABOVE: samples of dyed pleated silk.

LEFT: Fortuny's design for a silk-pleating machine, patented in Paris in 1909 (Brevet 414,119).

OPPOSITE: Liselotte Höhs wearing one of her magnificent Delphos dresses.

BELOW: the diagrams for one of Fortuny's patent applications for a dress design, 1909.

MARIANO FORTUNY 113

world, even though his first and last love remained the brocades and printed velvets of the Renaissance, familiar in the works of Titian, Paolo Veronese, and Vittore Carpaccio. He did not worry about the distinction between original art and that copied from folk traditions; he was happy to acknowledge the inventive genius of those who had created the wonderful patterns and colors upon which he relied and was proud of his role in bringing their work back to life. He patiently unearthed and learned techniques and skills that had been lost, and Henriette assisted him. Fortuny compiled a kind of census of the world's motifs and printing processes. He was the first in Europe to use Japanese *katagami* paper stencils, which made it possible to work on much larger pieces of fabric.

ABOVE: another of Mariano Fortuny's many design labels.

RIGHT: a studio photograph by Fortuny of various experiments with draping on mannikins.

OPPOSITE: a mauve Delphos. This model is held together by its delicate iridescent *pâte-de-verre* beads, specially made in Murano.

In 1924 the magazine *Renaissance des Arts* rendered the following homage to Fortuny: "His dresses of Arabian damask, his jackets cut from ravishingly nuanced fabrics, his silk-velvet coats stamped with gold and silver—all these things have made him venerated in Paris society."

Paris society wasn't alone. If the timeless and incomparable Fortuny vogue had been a great success before the Great War, afterward it was the chosen fashion of the international set, especially, of course, in Venice, where spectacular parties were given between the two wars. On these occasions Fortuny's extraordinary velvets and brocades, reproducing Tuscan, Genoese, or Flemish originals in wonderfully hazy tones, seemed to reinforce one another's presence, marvelously complemented by the architecture within which the great balls were held. Whole centuries were resurrected at soirées like the one given by Count and Countess Volpi for the marriage of their daughter to Prince Carlo Maurizio Ruspoli. Not all of the dresses worn came from the workshop of Fortuny, but the party was indubitably a Fortuny party.

At this celebrated event all the guests, whether from the aristocracy or the fashionable intellectual milieux of Europe, were dressed in the style of the palazzo. They included Countess Morosini, Countess Balbi-Vallier, the Duchess de Gramont, Princess Mdivani, Mme José-Maria Sert, Lydia Borelli (later Signora Cini), Countess Schoenbrunn. Countess Volpi wore a Renaissance-style dress of Sicilian velvet; the others were in lamé, velvet, Florentine brocade, silver or glazed brocatelle, Scutari or Burgundian silks.

Next day, a play was put on at the house of the poet and patriot Gabriele d'Annunzio, at his villa near Lago di Garda, under the patronage of the Duke of Aosta. There the guests were more diverse than the day before, largely because d'Annunzio had dressed up several thousand students and neighboring villagers in the local peasant costume of the Abruzzi. He himself was dressed in the uniform of an air-force commander. The spectacle began with the firing of a cannon from the bows of his private yacht. This event was boisterous and public, but at the more exclusive ball on the terraces overlooking the lake that evening, the ladies wore Fortuny dresses that fluttered around them with fluid, transparent delicacy, as airy and insubstantial as the wings of insects, dancing among the flowers.

ABOVE: a printed-velvet drawstring purse with beads.

OPPOSITE: detail of a Delphos with *pâte-de-verre* beads.

MARIANO FORTUNY 117

THE FORTUNY DRESS

Eustace breasted the rather steep staircase that led, abruptly and without preamble, into Fortuny's Aladdin's cave. . . .

The sofa in front of them and the table between them were soon deep in piles of silk and brocade. The room hypnotised Eustace. Colours were everywhere, on the walls, on the floor, on the painted ceiling; and the sunlight, filtering through the looped and pleated curtains, filled the air with radiant dust. It was like breathing a rainbow. Noiselessly, smilingly, the two women brought down bale after bale, piece after piece: here was a pattern of yellow and cream, wooing each other, almost indistinguishable; here wreaths and tendrils of green on a ground that was nearly white; here a soft blue with a mother-of-pearl sheen on it; here a cardinal red bordered with gold braid.

"I like that one," said Eustace tentatively.

"Do you?" said Lady Nelly. "I thought you'd gone to sleep." She narrowed her eyes a little. "No, it's too—too uncompromising. It wouldn't mix. One has to be seen with other people. She could wear it once or twice, perhaps, but that seems a pity with a Fortuny dress." . . . In a moment the whole length lay before them, a stretch of evening-coloured sky with silver tulips climbing over it.

"But we shall want much more than this," said Lady Nelly. "It has to be accordion-pleated. . . . If I'd been younger you'd often have seen me in a Fortuny dress."

"Are they very smart?" asked Eustace. . . .

"Oh no, they're High Bohemia, almost Chelsea. They're for off-duty—any kind of duty. They don't invite comparisons—they mean you've stepped away from the throng for a moment and want to be looked at for yourself—not stared at, just looked at with kindly attention and affectionate interest. A moment of not conforming, not a gesture of rebellion."

. . . The box had Fortuny's name on it. Eustace untied the string and lifted the lid. What he saw beneath the uncrumpled tissue-paper startled him. Twisted into a tight coil, as if wrung out to dry, lay the blue and silver of Hilda's dress. The heavy pleats, close-ribbed like a ploughed field, looked darker than he remembered. He knew he could never fold the dress again, so he contented himself with letting his fingers run along those grooves and ridges, so tightly drawn that he could feel their pressure. Yet what power for expansion did those pleats imply, what dreamed-of potentialities of movement for Hilda, the new Hilda! What an escape from the prison of her clinical clothes, the blue-black uniform that constricted all her movements! She could dance, she could fly, in this. . . .

". . . See what lovely material it's made of—I never saw anything like it."

She leaned across the table and took the skirt of the dress between her fingers, stretching the furled pleats, until they gave up the last of their blue and silver secrets. . . .

"I shouldn't be surprised if everyone wants to look at it," Minney said, letting go of the folds, which sank back slowly into their former lines as though endowed with conscious life. . . .

The blue and silver of the dress seemed to have woven their own moonlight round her.

L. P. Hartley,
Eustace and Hilda, 1947

ABOVE AND OPPOSITE: a Delphos worn with a long shawl of printed silk like a sari.

LEFT: a pleated Delphos with ruched sleeves and a gypsy sash.

OVERLEAF: a room in Palazzo Pesaro-Orfei used for painting. The paintings are by Fortuny and most are on Wagnerian themes.

118 MARIANO FORTUNY

Fortuny and the Theater

Fortuny was often called "the Little Leonardo" and the "Magician of Venice." Although his many talents justified such praise, the former epithet no doubt struck him as immodest, while the latter probably gave him a certain pleasure. There was, after all, a dash of sorcery in his work.

The world of theater was first revealed to Mariano Fortuny by a friend of his mother and uncle, Rogelio Egusquiza, whose passion for the music and opera of Richard Wagner led him to collect all sorts of art and memorabilia related to the works, especially *Parsifal*. At his death he directed that a painting of the Grail be placed before his coffin and a replica of the sword of Titurel laid by his corpse.

Our friend Egusquiza, a painter and musician, went to Bayreuth, and returned a changed man, completely fascinated. He could no longer hear or see anything but simple harmonies, stark lines, gray and austere tonalities. He spent the rest of the winter telling me about the myths and heroes of the Tetralogy. As a teenager, I was completely drowned in these fantasies.

From an early age Mariano was ripe for the world of Wagner. His own first visit to Bayreuth around 1890 was also a revelation, a thunderclap that echoed through the rest of his life. Once captured by the Wagnerian vision of art, he placed all his own creative, technical, and scientific resources in the service of the Master, whose art he felt had been so poorly served by the unimaginative sets, costumes, and lighting then in use.

At twenty-five Mariano won a gold medal at the Munich Exhibition for a painting with a Wagnerian subject. It was a profession of faith: Wagner was to remain a passion with him till the day he died.

In 1899 he staged a performance of Gilbert and Sullivan's operetta *The Mikado* at Palazzo Albrizzi. That same year d'Annunzio invited him to collaborate on a production of the poet's still-unfinished verse drama *Francesca da Rimini*, written for Eleonora Duse. Soon afterward the great Milanese opera house La Scala also commissioned Fortuny to design sets for a production of Wagner's *Tristan und Isolde*. These first attempts at scenic design remained incomplete, but the two projects lit a fire in the young artist's mind.

D'Annunzio's plays *Francesca da Rimini* and *La Parisina* were conceived as the first two parts of a trilogy about the Malatesta family, rulers of Rimini. The third play was never completed, probably because d'Annunzio was discouraged by the mixed reception of the first two, despite the presence of the wildly popular Duse. For *Francesca da Rimini*, Fortuny set to work enthusiastically with d'Annunzio and Duse and created a number of maquettes of the sets and costumes. It was for this project that he first proposed to use his lighting invention, the dimmer switch, in order to achieve the effects of atmospheric

ABOVE: a portrait of Mariano Fortuny by Nadar.

OPPOSITE: Fortuny stands before the stage curtain he designed for the Comtesse de Béarn's theater in 1906.

Actors in the 1937 production of *I Trionfi* in their Fortuny costumes.

My dear Mariano,

This morning, in the teeth of a gale blowing outside, I had the great joy of putting the final touches to my tragedy, the fruit of much painful labor—so painful, indeed, that I could see no end to it.

And now your long-awaited letter has arrived to extinguish all my happiness. To my fraternal soul, the treachery of Paolo Malatesta is far less cruel than your defection.

Everything was arranged, I thought, when we met at Capponcina. You promised to support my work. We had even agreed upon a date, the beginning of December.

Since that meeting, I have worked with you at my elbow, a silent, unseen collaborator. As I composed my work, verse after verse, I kept your art firmly in mind. You helped me find images of such force and beauty that when you finally read them they will make your heart swell with the consciousness of your power. There is no such thing as a movement or a tragic circumstance without pictorial or plastic quality. Without your collaboration, my work is crippled. I don't know if I have managed to make you understand how deeply your promise of working together has influenced me.

I imagined a whole world of line and color that you would bring to life. I profoundly believe—as you obviously believe yourself—that an artist's word (spiritually speaking) is more binding and sacred than any commercial or legal engagement. I must, of course, emphasize the serious harm that this will do to Madame Duse. The theater has been reserved, the actors have signed on; more than one not inconsiderable sacrifice has been made at the altar of this ideal project. And yet, at the last minute, when with a shout of triumph I had scrawled "Finis" at the bottom of my manuscript, you saw fit to withdraw and send me your refusal by the mail. Everything is collapsing. We shall never again have so splendid a chance to make this longed-for dream a reality.

I don't need to tell you the extent of the pain you have caused me; it is all the more devastating because this is the first time that I have surrendered myself, heart and soul, to the illusion of a joint creative project.

I would like to think that you are not unaware of my keen sadness and disappointment. Like me, you are in the habit of making great efforts. I would like to see you again, to speak with you, to acquaint you fully with the work I have done. I can come to you in Venice immediately. Please telegraph me as soon as you receive this letter, without fail. We must talk this over.

Act Four is crucial; a tragic effect gives it extreme simplicity, in contrast to the richness and complexity of the other three.

My dear Mariano, spare me this anguish. Don't break the word you so nobly gave me. I have spent the last three months in communion with you, forcing myself to the limits of my abilities and beyond. I did so in the certainty that my reward would be in our two wills combined.

I cannot believe you will desert me, such is my faith in your loyalty and in the purity of your spirit.

With love,
Gabriele [d'Annunzio]

and variable lighting that he so loved. However, he soon discovered that the poet and his leading lady were counting on him not only to design the production, but also to direct it. After much hesitation, Fortuny refused the offer, which seemed to him too far removed from his area of expertise. The job was then given to the impresario Angelo Rovescalli, who rejected Fortuny's designs.

In 1901 Fortuny went to Paris to study theatrical lighting. Paris, the City of Light, was at the time quite literally a center of innovation in electrical engineering, as well as the capital of art. Claude Monet and Paul Cézanne were showing light-filled paintings there, and Fortuny met the dealers Ambrose Vollard and Daniel-Henry Kahnweiler, the young Picasso, and the great Russian collector and patron Sergei Shchukin, who was commissioning magnificent avant-garde paintings for his home from Henri Matisse.

Still, it was not painting that attracted Fortuny to Paris, but the new technology of electricity—especially its application to the problems of theater lighting. The invention of electricity had transformed the theater, but it made the deficiencies of painted sets and backdrops all the more visible, and placed actors under an unattractively fierce scrutiny. With the loss of gas lights, something of the illusionistic quality of the stage vanished too. Fortuny was fascinated by the idea of lighting the Wagnerian *oeuvre*, especially the *Ring* cycle, in new and experimental ways. He felt strongly that the great thundering god Wotan would never appear as Wagner had conceived him if he was not properly lit. But the electricians who could help him with these ideas did not live in Venice.

In Paris he settled in rue Washington, just off the Champs-Elysées, but his studio there soon proved too small for his project and he moved to a larger one on boulevard Berthier. His goal was to build a movable theater made of materials

TOP: a maquette for a Fortuny set of *Die Meistersinger*.

ABOVE: a maquette designed by Fortuny for the second act of Wagner's *Tristan und Isolde*, 1900.

that would reflect and respond to light in controllable ways. The idea may seem simple, but it represented an astonishing sea-change in set design at the time.

Although Fortuny had not yet decided on a shape for his structure, he had ideas about materials and a lighting system for it. On April 21, 1910, he took out a patent for a system of indirect stage lighting. He objected to direct lighting on the grounds that it erased the sense of mystery essential to the theatrical experience. Raw, unnuanced illumination trapped the actors onstage, exposing them too much and robbing them of their magic. If light was too strong or direct (and electrical light, still new to nineteenth-century eyes, was very bright), the artifice of the theater was revealed rather than transcended. This gave the stage an air of ludicrous artificiality and deprived it of that sense of a world of gods, fairies, and heroes into which the spectator expected to be drawn.

The genius of Fortuny's design was that his electrical lamps were not pointed at the actors, but at an overarching structure made of neutral screens, or scrims, creating indirect effects through reflection. He had not yet worked out the precise shape of the structure but imagined it as a dome or half-dome. This would have two purposes: in addition to casting indirect light, it could also be used as a neutral backdrop onto which background colors or images of scenery could be projected. The dome would be at once set design and light source.

The idea's economy of means appealed to him, and he worked on it assiduously. Finally, in 1902 he was ready to show the concept to others. He went first to theater professionals: Sarah Bernhardt, the Coquelin brothers, and the Wagnerian producer

ABOVE: the Carro di Tespi traveling theater in Rome, 1929.

ABOVE RIGHT: an adaptation of the Fortuny dome for the Carro di Tespi, 1929.

Friedrich Kranich, who reacted with extravagant praise. They were especially thrilled with the clean, uncluttered quality of the dome, which permitted actors great freedom of movement, and with the sense of atmospheric depth and rhythm it offered. Today, the use of a neutral screen with projected images or lights at the back of the stage is a commonplace means of depicting the sky, stars, or infinite space; it is called a cyclorama. Few people know that Fortuny invented its prototype.

On January 20, 1902, the first mobile Fortuny half-dome, equipped with indirect lighting, was erected in rue Saint-Charles. The following year Fortuny met the Swiss theater designer Adolphe Appia. The encounter was to prove pivotal for the future of the stage.

Appia had dedicated his life to music and the theater. He had studied music for eight years in Geneva, Zurich, Leipzig, Paris, and Dresden. At age twenty he had been present at the première of *Parsifal* in Bayreuth. In 1888 he set out to reform the creaky art of theater direction, beginning with a two-year apprenticeship in theaters in Germany and Austria. He was greatly influenced by Wagner's ideas about the need of unity in a theatrical production, and began making notes for a production of the *Ring* cycle. In 1895 Appia published a book on the staging of Wagnerian drama. This was followed in 1899 by a monograph on music and staging. In 1900 he completed a book on new ways of directing for the theater, while at the same time producing numerous sketches and drafts for productions of Wagner, including *Das Rheingold*, *Die Walküre*, *Tristan*, and *Parsifal*.

Appia was a passionate Wagnerian, obsessed with perfecting the relationships among music, space,

ABOVE: a design sketch of Fortuny's mobile folding dome.

ABOVE LEFT: the frame and scaffolding for the dome.

light, and set decoration, which he called painting. He was a thin man of middle size, with a black pointed goatee, a straight nose, and long eyebrows. He had an air of easygoing seriousness; he and Fortuny got on well from the start—no surprise given their shared views on the theater. "Lighting," Appia had written in his first book, "is the most important element of fusion available to the director." In *La Revue* on June 1, 1904, he wrote, "Mariano Fortuny, an artist who is well known in Paris, has discovered a completely new system of lighting, based on the properties of reflected light. The results are extraordinarily felicitous, and this brilliant invention is bound to create a radical change in attitudes to lighting in all of the world's theaters."

In 1904 the two men began to work together on the restructuring of a private theater belonging to the Comtesse de Béarn in rue Saint-Dominique. They were well matched, both preferring sober, serene designs that made much use of open space and simple silhouettes. The goal was to serve drama plainly and with grandeur. On March 29, 1906, Mme de Béarn's theater witnessed the triumph of Fortuny's new lighting system. The work was a ballet by Charles-Marie Widor performed by Carlotta Zambelli and the Paris Opera Ballet. Two sets were used. Widor himself was thrilled: "For the first time, on March 29, 1906, set design has entered the realm of music—in other words, the realm of time—whereas until now it was only able to develop in space. This date will be remembered as a red-letter day in the history of theater." Fortuny himself described his system in an article published in *Le Menestrel* on April 15, 1906:

ABOVE LEFT: a scale model of one of the first theaters designed by Fortuny using the new lighting techniques made possible by his dome design.

ABOVE CENTER AND RIGHT: a 1908 maquette for a play by Hugo von Hofmannsthal, showing different light effects.

OPPOSITE: interior and exterior views of a maquette for a Festival Theater devised by Fortuny and Gabriele d'Annunzio in 1912.

MARIANO FORTUNY 129

Whatever the perfection of our present systems of stage lighting, it cannot satisfy us because it is yellow; because the restricted number of available red, blue, and green hues makes it appear impure; because direct, focused, undiffused light is no more suited to actors than it is to painters; and because the lamps [lightbulbs] gradually darken with use and it is very difficult to reproduce effects with any degree of consistency. The problem, in brief, is to project a light whose intensity remains constant against a surface of whatever color is deemed suitable.... The system we introduced the other day operates as follows. A double electric light source placed on the stage, above the curtain, illuminates the set. There is no backdrop; in its place is a broad dome made of white fabric, like the inside of a balloon. Depending on what is placed in front of the light source (e.g., tinted silk or glass plates with clouds painted on them) the dome assumes life and color. We saw the blue sky of a June morning, the first signs of a storm, then a sunset—in that order. The dome can appear as the vault of heaven, the limitless horizon, the air we breathe, the atmosphere, the very stuff of life.

The painted-metal reflector of an adjustable lamp. Similar lamps are reproduced on pages 30 and 33.

Fortuny's technical description of his invention was as skilled as the invention itself. He meticulously described the role of the chief electrician, who operates the control panel and "sees everything and controls everything, at will creating light and shade, calm weather and tempest. He uses all the colors of the prism to match the author's thought; he has organized everything in advance, and his score [i.e., technical script] is synchronized with that of the orchestra conductor."

Thus the Fortuny system consisted of special lighting equipment creating effects by projecting colors and images on the inner surface of a mobile dome. This vault of fabric was affixed to an articulated wooden frame like the hood of a baby carriage, and could be opened up or collapsed in a few moments. If the stage was supposed to represent an interior, the fabric could be drawn up and hung from the proscenium arch. It could be manipulated as easily as a simple flat backdrop. Among its other applications, it could be used as a simple,

A scene from a performance in Mme de Béarn's theater, 1906; note the effect of indirect lighting, which was revolutionary at the time.

portable outdoor theater. It was manufactured by Forlamini, the world's principal manufacturer of airborne dirigibles. The Fortuny dome had unusual acoustics. Actors quickly found themselves competing for certain areas of the stage, from which their voices had exceptional resonance.

These years in Paris were a period of remarkably prolific creativity for Fortuny. The triumphant debut of his dome at Mme de Béarn's theater in March 1906 occurred three years after the inventor had first applied for a patent for it and two and one-half years after he had applied for the patent for his indirect lighting system.

The patent for his inflatable concave dome was two years old, that of his multiple-positioning arc lamp was one and one-half years old, and that of his mixed lighting system a year old.

In May, wasting no time, he founded a company to build his dome and lighting system, in association with a German firm named AEG. Based in

Mariano Fortuny, second from left, at a rehearsal of *I Trionfi* in the courtyard of the Castello Sforzesco, Milan, 1937.

Berlin, it was named the Beleuchtung System Fortuny Gmbh.

Thus, it was at the Kroll Theater in Berlin that Fortuny set up his next dome. That year he met Max Reinhardt, the great German theater director and producer, and the Austrian playwright Hugo von Hofmannsthal. His relationship with these two highly creative figures began auspiciously, but before long artistic disagreements began to surface. In particular, Fortuny did not see eye to eye with von Hofmannsthal when the latter asked him to direct *Electra*. Fortuny's own taste was for realism, while the Austrian preferred a stylized, archaic symbolism.

In 1907 Fortuny prepared diorama sketches for a Venetian Ball project, to be presented at an exhibition of Italian art in London. That year he also joined forces with d'Annunzio and the architect Hess to build a theater, to be named the Théâtre des Fêtes, and found a company to stage d'Annunzio's works. This seemed an ideal opportunity for Fortuny to present all his research in stage lighting, sets, and costumes in one place: the Fortuny dome, Fortuny lighting, Fortuny sets, and Fortuny costumes, made with Fortuny fabrics all would be combined in a single, unified production.

Alas, the project faded to nothing. Although the two men were fond of one another and understood one another, every business relationship between them was doomed to fail. Responsibility for the failure of the Théâtre des Fêtes belongs to d'Annunzio, who ran away to his villa at Arcachon with a new lover, abandoning his plans and his previous mistress on the very morning when he was supposed to be signing the contract with his partners.

Fortuny was characteristically unmoved. He depended on no one; he merely turned his attention and energy back to his beloved textile business and undertook a number of other projects for stage sets and theater designs. In 1912 he worked on one of the earliest productions of the Ballets Russes, *Le Dieu Bleu* (*The Blue God*), based on a text by Jean Cocteau and Frederigo de Madrazo, with music by Reinaldo Hahn. This Orientalist fantasia, set in India, had only a few performances, despite the collaboration of an extraordinary group of artists: Serge Diaghilev produced, Vaslav Nijinsky danced, and the superb costumes were by Léon Bakst.

In 1929, in collaboration with the Leonardo da Vinci Society, Fortuny built a mobile dome at Milan for the traveling theater company of Giovacchino Forzano, Giacomo Puccini's friend and librettist. This was known as the Carro di Tespi, the Chariot of Thespius; it traveled the length and breadth of Italy for many years, enchanting audiences, and later became established as a Puccini theater festival that still functions today.

Now began a long period of successful theatrical designs. In 1931

Fortuny staged Wagner's *Meistersinger* in Rome. Legend has it that when he was designing the sets for this production he went to stay in the mountains and waited there until he could witness a storm, which he photographed for later reproduction on stage. That same year he designed the lighting for an exhibition of French art in London. In 1937 he was hired to design and direct the opera *I Trionfi*, performed at the Castello Sforzesco in Milan. In 1944, despite the war, he worked at La Scala, designing sets for the opera *La Vita Breve*, by his compatriot Manuel de Falla. This time he took photographs of the old city of Granada and projected them as backdrop images. That year he also designed sets at La Fenice in Venice for a Goldoni play; so beautifully did they evoke Venice that they were reused in 1958 for Wolf Ferrari's *Il Campiello*, at the same theater.

While Fortuny's love for the theater was strong, it was obviously not his only passion. His many interests tended to complement one another, and he used his research in lighting and shadow effects for purposes other than the stage. In 1908 he designed the lighting of the foyer of the Paris Opera; this was followed by new lighting for two of Venice's most precious art collections: the Scuola Grande di San Rocco and the Scuola di San Giorgio degli Schiavoni in Venice, whose great painted chambers were lined with marvelous Tintoretto and Carpaccio canvases. Later, he was hired to install new lighting at Madrid's Teatro Real.

In sum, he achieved extraordinary success in many fields: as costume designer, set designer, lighting technician, painter, interior decorator, couturier, textile designer, and engineer. Remaining aloof from most contemporary tastes and trends, he nevertheless worked in the very forefront of new artistic ideas. He maintained the stance of a recluse, living in his own exotic dream world, but when necessary traveled far in quest of inspiration.

RIGHT: Fortuny, in an elegant white suit, stands in front of the Carro di Tespi theater.

OVERLEAF: a Fortuny Saturno lamp silhouetted against a gauzy Fortuny curtain over the antique windows of Palazzo Pesaro-Orfei.

PAGE 136: a transparent gold-printed gauze floats over the ruby pleats of a Delphos.

TEXTILES AND CLOTHES

Doretta Davanzo Poli

Mariano Fortuny was the ideal Arts and Crafts figure. Like William Morris before him, he dreamed of reforming every aspect of applied art. All his work was based on this premise, though its impact was felt later and in a different way. Fortuny was inspired by the decorative styles of the past, but with his particular flair he made them his own, modifying proportional and chromatic relationships to create clothing ensembles that were radically new and original. His work was extremely subtle, achieving variations in effect through almost imperceptible changes—the elimination of a detail or the combination of certain colors. He was quite ready to use unusual or unexpected fabrics and technical processes to arrive at a new aesthetic result.

He was called a magician and alchemist by the artistic and literary intelligentsia of his time (among his admirers were Marcel Proust and Gabriele d'Annunzio); indeed, these are probably the best terms in which to describe him—particularly if we consider the context in which he lived and worked.

Surviving photographs of his various workshops, studios, and homes show these places as they were during his life, and as they were preserved for many years after his death: They had

ABOVE: Mariano Fortuny, *Portrait of Henriette Negrin Fortuny*, 1915; distemper on board, now in the collection of the Museo Fortuny, Venice.

OPPOSITE: eight Fortuny patterns printed on velvet, including arabesques drawn from Persian carpets, Renaissance-revival grapevines, heraldic emblems, and the stylized tulips of the Ottoman Empire.

PAGE 137: some of Fortuny's handbound notebooks containing his designs and sketches.

high ceilings and long polished tables used for printing and retouching fabrics, and they were lit by great bell-shaped lamps that Fortuny himself had designed. Some rooms were filled to bursting with wood or metal blocks and other equipment for printing cloth by hand; others were cluttered with strange machinery (half furnishing, half tool) invented by him: easels with drawers and canted surfaces; printing rollers; side tables littered with test tubes, vials, chunks of alum, acids, solvents, dissolving agents, metals in solution, and other weird potions. Alas, many of these objects were dispersed in the 1950s and 1960s, while others were literally tossed into the nearby canal just south of Palazzo Pesaro-Orfei, when, for some foolish reason, the rooms were cleared. Egregious polluting of this kind has since been banned in Venice; but had all Fortuny's possessions been properly preserved and inventoried, perhaps today we might be able to reconstruct some of the unique printing and manufacturing processes he used, many of which are irretrievably lost. Regrettably, this priceless legacy was not acquired by Elsie Kruse McNeill Lee, Fortuny's dealer in America as well as his *protegé* and artistic heir.

Not all the remnants of Fortuny's working life were destroyed. Many objects were dispersed, sold to anyone who wished to buy them. There were sacks of beads, buckles, glass accessories, *passementeries*, trimmings, braids, borders, bolts of printed velvet and muslin, and hundreds of white-canvas master patterns with motifs marked in black. Great wooden wardrobes, draped with fabrics from the shop, held rolled-up Delphoses and other dresses. His sorcerer's workshop, laboratories, and storerooms at Palazzo Pesaro-Orfei were complemented by the rich furnishings of the apartments on the *piano nobile*, or main floor. In the Venetian style, this consisted of a vast principal room lit by broad Gothic windows with transparent or pale tinted bottle-bottom glass panes; it was hung with drapery and tapestries. These were

Three printed silk velvets:

TOP TO BOTTOM: gilt-silver tulips, inspired by a sixteenth-century Turkish textile; a gold-and-silver Japanese motif; a pomegranate design inspired by an Italian fifteenth-century fabric.

ABOVE: a silver and indigo-blue velvet based on an eighteenth-century reinterpretation of a Renaissance floral motif.

OPPOSITE: a hooded cape in silk velvet with the pomegranate motif of which Fortuny was so fond, printed in gold. The design imitates a fifteenth-century double- or triple-cut Italian velvet.

140 MARIANO FORTUNY

all made by Fortuny himself, as were the Spanish–Moorish furniture and lamps, and many of the engravings, drawings, paintings, proofs, and sketches. He had a highly eclectic art collection, too, comprising sculptures, paintings, woodcuts, arms and armor, carpets, fabrics, ornaments, bits of exotic Oriental and Arab costume, and ethnographic objects. These resided in the bookshelves of his private studio, or in Room 8, as Fortuny's painting room was called, and gave it the air of a cabinet of curiosities.[1] The bookshelves were also home to row upon row of rare books and most of his photographic archives, filed in albums carefully sorted by subject and elegantly bound in his own famous cloth.

In the 1960s the palace's contents were liquidated, mostly by order of the Fortuny heirs following the death of Henriette in 1965, with the residue vanishing bit by bit until the 1970s. The collector Liselotte Höhs, wife of Fortuny's solicitor and a prominent collector, tried to buy as much as she could, to prevent a total break-up of Fortuny's legacy; she enlisted the support of friends, artists, and public and private institutions. Unfortunately, Fortuny's reputation at this time was at low ebb, and museums were in the main indifferent. The fate of the textiles is particularly interesting to us, not only those he produced himself, but also the antique ones that had provided him with such an inexhaustible source of inspiration.

ABOVE LEFT: a pattern based on fossil trilobites in staggered rows, surrounded by delicate coiling plant stems; this stunningly original design has a faint suggestion of the ancient Eastern tree-of-life symbol.

ABOVE RIGHT: this elaborate design, based on floral images and fanciful Rococo shapes, is inspired by early eighteenth-century European composite fabrics.

OPPOSITE: a long court mantle of gold-and-silver printed velvet, trimmed and lined with fur to mimic a Renaissance style.

The Textiles

The first Fortuny collection of historic fabrics had been gathered in Spain by his parents, especially his mother, Cecilia. This was sold in Paris in 1875, together with the family's more valuable art collections, after the death of Fortuny's father. The catalogue of the sale listed about sixty textiles, not including rugs and tapestries. Dupont d'Auberville, an art historian and textile collector, noted the rarity of these precious stuffs. He made particular mention of a "beautiful piece of fifteenth-century velvet with a four-color warp," some marvelous "gold bouclés," and some "brocades on a silver ground, made in Lyon."[2] On the remnants of this collection Mariano Fortuny y Madrazo began another, broader in number and variety of types, which was maintained and added to by his sister, Maria Luisa; unfortunately, part of it was sold in 1915.[3]

We can estimate the size of Fortuny's own collection of textiles by examining the existing records of what was sold after his death. About 400 pieces were purchased in 1965 by a bank, the Casa de Risparmio di Venezia. Some 130 Coptic fabrics went

Two antique textiles from Fortuny's collection, photographed by him.

TOP: a cut velvet with appliqué embroidery; ABOVE: a mid-fifteenth-century dalmatic, an ecclesiastical vestment.

ABOVE: a gold-printed silk velvet with blossoming flowers and twining stems, in the Italian Renaissance style.

LEFT: a gold-printed silk velvet, dyed with cochineal, in a double-branch pattern, based on a fifteenth-century Venetian design.

OPPOSITE: gold-printed silk velvets with fifteenth-century Venetian- and Florentine-style pomegranate motifs.

CLOCKWISE FROM UPPER LEFT: a sixteenth-century-style red textile alternates branches with three artichokes and three pomegranates to form a reticulate repeat with ogival links. In the center of each ogive is a thistle framed by raspberry bushes, or a pinecone nestled in pomegranate flowers. The Spanish–Moorish border has vine tendrils interspersed with leaves.

A Renaissance *a griccia* design is elaborated with a pair of vertically intertwined serpentine tree trunks that sprout slender branches with thistles and small pomegranates. These are interspersed with flower shapes with pinecones at their centers.

A gold-and-green textile uses the motif of large amphorae with ornate handles set on a central axis between volutes facing acanthus branches. From these spring vine tendrils bearing pomegranates, pears, and a large tulip. Two textiles in Fortuny's collection of historic fabrics had this pattern in a red variant.

A blue velvet printed with alternating acanthus branches and flowers and a seven-petaled flower with a further shoot in the center. This Renaissance-inspired pattern, known as *a cammino*, incorporates a number of Islamic decorative features, such as the well-known Rumi leaf.

OPPOSITE: a court mantle of gold-printed silk velvet, with a Venetian pomegranate motif and braiding inspired by Middle Eastern embroidery.

RIGHT: a printed velvet in a Renaissance flowering-thistle pattern, called *a griccia*. Fortuny borrowed the thistle motif, but used it in an unusual horizontal repeat.

to the collection of the Castello Sforzesco museum in Milan; another 40 or so Coptic pieces went to the Centro Internazionale delle Arti e del Costume, then housed in Palazzo Grassi in Venice, and to the Museo Fortuny. These were later reunited under the auspices of the Civici Musei Veneziani, with other fabrics and ornaments from the original collection, dating from the thirteenth through the eighteenth century. Another lot of 130 textiles was sold directly to Liselotte Höhs by the heirs. This makes a total of more than 700 pieces. We know of another 550 pieces, for they were photographed by the artist, filed in three albums bound in printed serge, and stored in his library.[4] Analyzing all of these, we can trace not only Fortuny's creative sources but also, to a degree, the history of the art of silk manufacturing itself.

Anne-Marie Deschodt has quoted the lush passage from Henri de Régnier's book *L'Altana* describing the great chest in which the Fortunys kept their most precious and delicate stuffs, and the ritual way in which, from time to time, they brought forth their treasures to be displayed.[5] These ranged from church vestments to court finery, doge's and caliph's robes, men's and women's articles of clothing, and textile lengths, some no more than threadbare fragments. The Museo Fortuny still displays some of them today.

A vogue for collecting applied arts swept Europe in the second half of the nineteenth century, following the Great Exhibition of 1851 at the Crystal Palace in London. Interest was

ABOVE: two versions of a typical Renaissance *a cammino* design, with a pattern of palmettes and thistles in horizontal and parallel repeats separated by slender knotted tendrils. Some of the details are Islamic, such as the elements called "three moons" and "leopard spots."

TOP: a printed cotton imitating fifteenth-century Italian velvet, with a symmetrical pomegranate motif.

ABOVE: a printed cotton with a pomegranate motif and raised pattern, in the fifteenth-century Italian style.

OPPOSITE: silk velvet printed with a gold double-branched motif that owes nothing to the fifteenth century, although the surrounding blossom-and-tendril pattern does.

further aroused by the opening of the Museum of Manufactures in that city (later renamed the Victoria and Albert Museum). Nevertheless, the field of textiles and textile history remained largely ignored by the big museums, although a number of lesser museums and private collectors, especially in Italy and France, did begin to assemble historic textile collections. Among these were the Museo Poldi Pezzoli in Milan, the Museo Civico Bailo in Treviso, the Gandini collection in Modena (now part of the Museo Civico), the Peggy Guggenheim Collection in Venice, the Carrand collection (now in the Museo Nazionale del Bargello) and Museo Stibbert in Florence, the Sangiorgio collection in Rome, the Fondation Isabella Errera in Brussels, and the Edouard Eynard collection in Lyon. A market for specialized antiquities developed; tragically, this led to the systematic dismantling of the rarest and most coveted items. Old hangings and historic clothes were cut into pieces and dispersed among museums throughout the world.

Some of the newer schools of design and applied arts emphasized the function of art to educate, rather than simply teaching industrial techniques and processes. Their curricula included drawing from nature and study of the formal structure and decoration of ancient art objects, and this influenced fabric design, especially in England. Among the basic tools of this new teaching method was Owen Jones's book *The Grammar of Ornament*, published in 1856. He collected and reproduced flat, stylized designs from around the world, many of them based on geometric motifs, anticipating the concept of pattern as a system of reproduceable graphic structures. *Studies in Design*, published in 1874–76 by Christopher Dresser, showed the importance to a creative artist of knowing how fabrics are constructed and of analyzing them technically, by smoothness or roughness of texture, type of thread and weave, consistency, weight, draping and flow, durability, and use. Dresser loved Japanese art, which had recently been introduced to European audiences in a series of exhibitions, after the opening of trade with Japan in 1848. He accepted the need to design for mass production and emphasized decoration over craftsmanship.[6] In this he opposed William Morris, who championed the unity of creativity and hand-craftsmanship. The idea of beautiful

ABOVE: Agnolo Bronzino, *Eleonora of Toledo and Her Son*, 1550, Galleria degli Uffizi, Florence.

ABOVE RIGHT: Fortuny's reinterpretation of Bronzino's original Spanish velvet, in lighter, more delicate shades. Fortuny's own textile collection included a similar antique example.

design meant for mass production was taken up by such manufacturers as Liberty of London, which made printed textiles, and Louis Comfort Tiffany's Associated Artists, which made wallpaper, stained glass, lamps, and furniture. These designers influenced the work of Mariano Fortuny more than a little.

The invention of electricity and the growing use of artificial light greatly stimulated Fortuny's imagination.

He was always aware of the effects of light—indirect, diffuse, or reflected—on his textiles: Different kinds of light produced variations in their colors and delicate finishes. Likewise, he drew on his great historical knowledge of fabrics to hunt down beautiful patterns and motifs from an almost infinite pool of sources. "A fabric design," he once noted, "concretely captures a moment through the skill of the artist, who responds

unconsciously to the place and time in which he lives."⁷

Fortuny's milieu was one of famous painters and successful artists, of a taste for decadent and Orientalist *fin-de-siècle* style, and eclecticism, with houses furnished in antique bric-à-brac, luxurious draperies, and silk cushions. Photographs of his father's house and studio show such rooms, rather like the private apartments of the Italian poet Gabriele d'Annunzio at his great villa Il Vittoriale, near Lago di Garda in northern Italy. The critic Mario Praz describes this decor as "suffocating: deep sofas groaning under heaps of cushions, heavy curtains and *boiseries*, objects from two continents and divers religions assembled with such a devout sense of the profane that they demonstrated a kind of involuntary surrealism."⁸

Giorgio Sangiorgi, a textile historian and collector of fabrics, has noted a vogue among painters of the time for decorating their studios with old fabrics tossed about at random—fabrics that however worn or faded were "so full of an indefinable, shifting richness that in themselves they could supply sources of inspiration."⁹ This minor fad caused a rising demand for antique textiles and modern ones in the antique style, and it probably encouraged Fortuny to start his production line of printed textiles. In his autobiography he claims to have been inspired by a piece of very ancient fabric unearthed at a site in Crete: "In 1907 some printed fragments of cloth found in Greece encouraged me to conduct research on printing procedures from the past,

ABOVE: Fortuny at work in his library, surrounded by books, magazines, press cuttings, and fabric samples. On his shelves are encyclopedias and rare editions; at far left, one arm of his etching press is visible.

LEFT: this motif of leaves, branches, and pomegranates on a blue ground may be seen in fabrics worn by figures in Renaissance paintings, especially those of Piero della Francesca. Fortuny also created green and crimson versions of the same design.

MARIANO FORTUNY 151

OPPOSITE: a printed silk velvet with broad double-branched motifs and an arabesque border, in the Italian Renaissance style.

RIGHT: a printed velvet cape with a double pomegranate motif, inspired by a fifteenth-century Venetian textile.

after which my wife and I started a workshop in Palazzo Pesaro-Orfei to put into practice the methods we had discovered."[10]

He had already done sketches of Cretan clothing as early as 1906, based on notes in a book titled *The Prehistoric Tombs of Knossos*, published in London that year by Arthur Evans, the archaeologist of Knossos.[11]

Fortuny was never a skillful self-promoter, and as a result encountered financial difficulties more than once in his life—notably on the outbreak of World War I, when his English and French markets collapsed, and in 1929, when Wall Street crashed. Fortunately, the latter disaster had a limited impact on his business, thanks to the

ABOVE: this polychrome printed design derives from a sixteenth-century grotesque pattern. It is composed of slender plant arabesques, knotted and intertwined, surrounding flambeaux, Oriental-style flowers, and fantastic creatures.

A rose-color tapestry border inspired by mid-seventeenth-century Italian brocatelles: vine tendrils with curling leaves surround alternating thistles and tulips, in the Mannerist style. Venetian lace patterns of the period use similar botanical fantasies.

A wall border with feathery branching wreaths surrounding alternating bouquets of budding and blossoming roses, carnations, and irises. This is based on a seventeenth-century Italian textile.

A linen fabric printed with Neoclassical motifs: a narrow pink band with a continuous tendril of olive branches runs parallel to a pink ribbon tied in a bow and a square medallion with a cameo rosette.

timely intervention of his American agent, Elsie Kruse McNeill Lee. He struggled during the 1930s, when the fascist government prohibited the importation of raw materials into Italy from abroad. The final disaster came in 1941, during World War II, when the Fortuny manufacturing firm closed down.[12] In the last years of his life, although burdened by financial problems, Fortuny nonetheless wished to donate use of Palazzo Pesaro-Orfei to the Spanish Government (which he continued to represent in Venice as honorary vice-consul), while retaining the freehold. However, this came to nothing, although it was strongly supported by one of the heirs, Fortuny's cousin Madrazo, who was the Spanish Ambassador at the time.

ABOVE: a red-and-gold printed cotton imitates a late fifteenth- or early sixteenth-century Italian damask; below it, a black-and gold printed cotton copies an Italian Renaissance velvet. Its arabesque pattern comprises cockerels and dragons originally borrowed from Turkish textiles.

RIGHT: a tapestry border inspired by mid-seventeenth-century *lampa* motifs, including vines, small vases or amphorae, and interconnecting frames reminiscent of the strapwork of wood carving from the same period. Such decorations were originally embroidered by hand.

Fortuny's interest in fabrics, both from the artistic and the industrial point of view, was to make him famous far beyond his other activities. It began officially in 1907, when he first experimented with techniques for printing large rectangular lengths of voile (4.5 x 10 meters), which could be used as shawls or stoles, with geometric and plant motifs inspired by the Kamares ceramics of ancient Crete. These were first exhibited in Berlin in November 1907.

The American modern dancer Ruth St. Denis used Fortuny shawls in her choreography, demonstrating the scores of ways they could be draped around the body while permitting complete freedom of movement.[13] On the same occasion, the dramatist and opera librettist Hugo von Hofmannsthal predicted an immense success for these fabrics of Fortuny's, "which follow the body's movements so well . . . and marry so perfectly with women's changing moods of frivolity or contemplation."[14]

LEFT: a printed textile repeats a circular Coptic motif and matching border.

TOP: a print copied from Sicilian and Safavid Persian designs, mixed with creatures drawn from the medieval bestiary.

CENTER: a silver-printed velvet imitates an Italian Renaissance architectural frieze that in turn was based on a late-period Pompeian (ancient Roman) painting style called Mannerist.

ABOVE: a cotton print copied from a seventeenth-century Italian embroidery.

LEFT, TOP TO BOTTOM: an indigo-dyed cotton print with an African decorative theme; a cotton print inspired by eighteenth-century ornament; a thistle-and-pomegranate pattern in silver and orange; a simple cotton serge in coral red on turquoise with a geometric pattern concealing highly stylized animals inspired by pre-Columbian woven textiles. The thistle and pomegranate symbolized fertility and abundance in the Near and Middle East, and were often found in Italian fabrics made in the fifteenth to seventeenth centuries, when Italy traded with the Ottoman Empire. These themes were handled in detail and with great naturalism in Renaissance velvets.

BELOW: two fabrics incorporating Arabic scripts. The upper one is a cotton printed in gold on blue. At bottom is an ornate printed cotton with Qufic script over arabesques on a red ground.

LEFT, TOP TO BOTTOM: a printed tapestry pattern is inspired by the fabrics designed by the French decorative artist Jean Berain in the second half of the seventeenth century.

A printed design has clusters of tiny flowers separated by Persian-inspired palm fronds curving in alternating directions. The pattern is staggered diagonally, for an unusually dynamic effect.

A delicate rhythmic design of interconnected spirals of different sizes is arranged in a printed checkerboard pattern.

A pattern based on Indian–Asian decorative motifs typical of Kashmir incorporates a heart-shaped form called a *boteh* and a stylized cypress tree covered in flowers. Here they are printed alternately on the front and the back of the fabric, in diagonal sequences, creating a curious undulating effect with strong chromatic contrasts.

Fifteen prototypes for the Knossos shawl date from this period, each with a different border pattern taken from a Phoenician, Babylonian, Egyptian, or Minoan original, including scalloping, stylized scrolls and Greek key designs, palmettes, rosettes, lotus blossoms, lions, chimaeras, and griffons, printed in black and gold on a white ground. Fortuny painted a remarkable portrait of Henriette swathed in a Knossos shawl eight meters (26¼ feet) long and wearing a second elegant drapery like a veil over her head and shoulders (see page 169). These early printed textiles were made with a very simple system of wooden stamps, advocated by

BELOW: a textile with a dramatic contrast between the main field and the border. The pattern in the blue-and-cream border uses abstracted plant motifs based on late seventeenth-century textiles. The main area, with stylized golden elements (probably birds or leaves) on an orange background, reveals a clear Japanese influence.

158 MARIANO FORTUNY

Dresser, but Fortuny found the process both commercially and artistically limited.[15] He therefore studied the difficult and complex Japanese *katagami* printing technique, in which polychrome prints are made with a series of paper stencils, one for each color.

In the West this process was modified with stencils made of cardboard or metal, which made it possible to print very large fields, but these were cumbersome and expensive to produce. Fortuny patented a system of large stamping dies that could be fastened onto either a frame or a mechanical roller to print a continuous band. The system worked on a variety of fabrics, including even the thinnest silk. The cloth was coated with a gelatin and the design painted on in a bichromate solution, either by hand or using a photo-transfer process similar to that of photolithography. The areas of gelatin painted with bichromate became insoluble when exposed to light and stayed on the cloth in a fixed pattern when it was rinsed off. The technique could also be used in reverse, with the design rinsed away and the negative space around it retained. The patent described how this bichromate process, applied with stencils on a roller, created "an endless band, so that it [is] possible to print on a length of paper or fabric using successive impressions, each very complex, which an ordinary engraved [printing] cylinder cannot do." For a three-color print, "three continuous bands are used, with a design on each for the specific impression of a different color . . . such bands can be fitted together using fixtures like those used for motion pictures."[16]

A silk velvet printed with a floral motif is inspired by an early sixteenth-century Italian textile.

The spiral is an immemorial graphic symbol for the cosmos. Here, alternating single and double spirals are connected with broken lines to give an impression of great dynamism.

A complex interlocking design of wheel shapes with hexagons and six-petaled rosettes at the hub is probably borrowed from the symbolic repertory of East Asian textiles.

This two-color damask upholstery fabric reproduces a design from the second half of the seventeenth century. The leaf forms are rendered very schematically in a simple modular structure with a repeat that balances positive and negative space. This, as well as the motif of flowering plant sprigs with shoots at the center, is typical of Italian Baroque design.

The theme of ribbons alternately knotted and interlaced to form arabesques is borrowed from an Islamic textile tradition.

MARIANO FORTUNY

The first Mariano Fortuny company, formed to promote "fine and applied arts," as its charter states, was established on December 30, 1911, by the artist and his mother, Cecilia. Its premises were in her home in Palazzo Martinengo, Calle del Traghetto, San Gregorio, no. 178, Venice, and its registered operating capital was 10,000 lire, invested in equal parts by the two founders. Mariano agreed to place at the company's disposal his "technical and artistic systems and procedures in his field of specialization."[17] The products of this first effort were shown at the 1911 Paris Exposition des Arts Décoratifs, where they were hailed as a triumph. Enthusiastic critics spoke of the "miraculous fabrics from Palazzo Martinengo . . . printed textiles conceived by Fortuny's multifaceted artistic brain," and of "ladies' garments, tunics, scarves, veils, Persian, Indian, Greek, and Cretan chemises; light Egyptian *ghanduras*. . . . And what can we say of the golds printed on these fabrics? Venetian golds, red golds, pink golds, white gold, blue gold, the gold of flowers, poison golds?"[18]

The first company was liquidated on February 15, 1916, and reconstituted under the same name with Mariano Fortuny as sole proprietor. In his registration with the chamber of commerce on March 9 of that year, he stated that his firm produced "handprinted silk."[19] On March 16, 1925, he listed "ladies' garments" among his "principal manufactured articles"; indeed, he had been making these all along. He also declared that he employed forty female workers.[20] On his death in 1949, this privately held company became

TOP: a cotton bouquet print inspired by late sixteenth-century Persian and Turkish designs that were imitated in France in the seventeenth century.

ABOVE: a cotton print imitating velvet, reproducing classic decorative themes of sixteenth-century Italy.

A symmetrical cotton print, reproducing a sixteenth-century Italian vase motif.

the property of his wife, Henriette Negrin. By then it was not producing, but only selling the existing stock of "artistic printed silk fabrics."[21]

In fact, Fortuny had two distinct companies: the privately owned one and a joint-stock company, the Società Anonima Fortuny, whose president was Fortuny's friend Giancarlo Stucky. The former specialized in handprinted silks; the other was partly mechanized, and specialized in "the mechanical printing of fabrics of all kinds except silk and velvets [especially cotton], as well as the mechanical printing of wallpapers and photographs according to the patents and methods devised by Fortuny." This latter firm was established in 1919 and registered with the local chamber of commerce on July 7 of that year. Its offices were not far from the two Fortuny palaces in Venice, in the immense Palazzo Grassi, Stucky's home. Later, it moved to an industrial building on the island of the Giudecca, at Riva San Biagio no. 805.[22] Fortuny explained: "We added the cotton fabrics later, for which I had invented special equipment so we could produce more. . . . To do this we started a limited-liability company, but we have maintained the [same] level [of quality], since the aim of all my work is to produce art."[23]

In 1927 he proudly reported to his shareholders that the business had broken even and that he had perfected his original products as well as managing a gradual, prudent entry into new markets.[24] As we have noted, the company began to have problems during the Depression of the mid-1930s, when the Italian fascist regime began imposing

BELOW: a reproduction of a two-color upholstery damask from the second half of the seventeenth century. Typical features of Italian Baroque textile patterns include the simplified plant and flower forms and the overall design based on a repeated heart-shaped space created by curving branches with flowers and shoots of vegetation at their centers.

ABOVE: a stunning cotton print that imitates velvet uses an exquisite sixteenth-century Persian motif of flying and perching birds surrounded by stylized leaves.

RIGHT: this elegant blue-and-white design places bouquets of flowers on a central axis, framed by garlands and supported by griffons or fauns. These groups alternate with foreshortened landscapes and mythological figures in the purest Rococo style.

MARIANO FORTUNY 161

manufacturing restrictions in order to promote economic self-sufficiency. Raw materials, such as linen and cotton serge from Manchester, England, were already difficult to obtain, and this problem was now compounded by long delays, failed deliveries, and the loss of major commissions.[25]

In 1935 the company's stock was devalued in order to wipe out losses due to poor sales, which in turn had been caused by "the insurmountable obstacles to the exportation of goods raised by recent events on the international stage."[26] The situation continued gradually to deteriorate, in part due to the loss of French and British credits when Italy entered World War II, until the business had to wind down altogether between autumn 1940 and spring 1941.[27] During the war the factory was damaged by bombs, but in 1946 Fortuny managed to convince his shareholders that the "right moment" had not come to sell it.[28]

In 1952, after Fortuny's death, the factory was sold to Elsie Kruse McNeill Lee. In 1951 Fortuny's wife, Henriette, had started a new company, called Tessuti Artistici Fortuny.[29] This was the company that finally closed on her death in 1965. It was reopened in 1994 by Elsie Lee, who became its chairman, with a staff of thirty employees.[30] This company still produces Fortuny fabrics, lamps, and clothes and has re-created the aura of mystery of the original; no visitors are permitted in the factory.

The preferred cloth of Mariano and Henriette Fortuny was a Lyonnais velvet with silk warp and weft (sometimes mixed with cotton or floss silk), but they used a wide variety of

TOP: this design, characteristic of the first quarter of the eighteenth century, comprises winding foliage and branches, pomegranates, tulips, and other flowers in a cascade of petals.

ABOVE: a reproduction of a Turkish embroidery pattern from the mid-seventeenth century, done in negative, or reverse. Ottoman textiles were generally woven in gold or silver thread.

other textiles as well: "weft velvet, entirely in cotton" from Prato, silk muslins, Moroccan silk crepes, silk bourrette, linen cambric, and wool. A silk and wool faille was often used as a lining (like satin or silk pongee) and was also used for the label: MARIANO FORTUNY VENEZIA.

The woven color of most of the textiles was white or raw, unbleached off-white that was then dyed, tinted, printed, and painted. Vial and Valensot, leading specialists in the field of textile manufacture, have confirmed this by examining the reverses of extant samples as well as the borders, which were usually turned and hemmed, so that the original color can be seen inside them.[31] The "effects of pronounced variation in color . . . were probably achieved with a paintbrush or sponge, as they were in Lyon. This technique could be applied to a fabric that had already been dyed or painted—in other words, on stuffs that had been prepared, prior to dyeing, with mordants or other solutions."[32] Successive overprintings of colors and designs could all be manipulated by hand or retouched later by adding or partly removing colors. Fortuny also sometimes printed his designs on the back, or reverse, of the cloth, to achieve unusual effects. And some irregularities were deliberate. "It is noteworthy that in certain pieces, the reverse surface appears much more clearly printed than the top side. It may be that certain chemicals unintentionally slowed penetration to the upper surface of an ink printed on the reverse."[33]

Fortuny used a system patented in October 1909. He described it as

a method of polychrome printing on fabrics, paper, etc., in several stages. The contours of the pattern are printed first, in a "compartmentalized" design, using an engraved plate; successive printings [of one color each] use either engraved plates or stencils to lay color on, more or less within the intended compartment area. This is to ensure that even if the placement [plate registration] is not quite perfect each color remains confined within the lines of the compartment; this takes into account the fact that dyes of this kind tend to spread by capillary action, due to the porousness of the fabric.[34]

Fabric may be naturally porous or made so artificially. The spread of the dye was controlled by the ink barrier made by the first impression, so that the effect was of exact color registration, without the need for much precision in the engraving or printing itself. Fortuny's written explanations of his techniques are insufficient to clarify all his tricks. Clearly, he modified printing effects and imagery as the creative impulse struck him. He sometimes printed both sides of a piece of fabric, for example, or only the reverse side, and then added painted colors or touches of lightening chemicals on the top side by hand. He set great value on the preparation of his pigments and on final retouchings with sponges and brushes, and some fabrics apparently had numerous layers of these additions.

Especially notable was his extraordinary way of introducing gold and silver into his fabric. He used both printed metallic inks and fabrics woven with metallic threads, sometimes combining the two techniques. He used

BELOW: a tapestry from Fortuny's home. The motif of branches with large oriental-style flowers and the broadly modular structure are inspired by a mid-seventeenth-century fabric.

ABOVE RIGHT: this whimsical tapestry fabric follows the designs done by Jean Berain in France in the second half of the seventeenth century: pavilions with fringes and tassels, architectural cornices, and consoles placed on central axes alternate with monkeys, fauns, and other exotic creatures, foliage, ribbons and swags of blossoms.

RIGHT: a sixteenth-century-style tapestry border with large opposing S-shapes, stylized flowers, and leaves. Fortuny did not reproduce the original design in its entirety; instead, he extracted one detail of it, which he enlarged and multiplied many times over.

MARIANO FORTUNY 163

powdered bronze or copper for gold ink and powdered aluminum for silver, sometimes with other colors added to vary the tint, or mixing all three metals together. His knowledge of dyes and the chemistry of cloth enabled him to achieve a remarkable brilliance in his metallic inks, while his familiarity with antique fabrics taught him the various effects that could be achieved with metallic threads woven in different warp and weft treatments. The use of gold and silver thread in brocades and other weaves to create herringbone, lozenge, or chevron patterns is very old, and Fortuny made full use of these traditional processes.

He also used a variety of printing processes to reproduce the optical effects of three-dimensional textiles: pleating, embossing, waffle-pattern, and other textures. One of his creations was a false-embossed stripe, usually on cotton serge, in which horizontal stripes of varying thickness were printed in metallic ink to suggest a slight indentation against the background. Since the effect is the same on the underside of the fabric, the technique appears to have been achieved through mechanical pressure, after the ink was applied; yet it probably was not. The pattern runs across the full width of the fabric, and has a second stencil design that shows up only in the areas printed with the metallic ink.[35] He also created a waffle-patterned velvet with a remarkable antique-style patina. Vial and Valensot do not believe that it was made with an engraved roller, which would have been very expensive, nor with the Lyonnais system of rotating stencils, which would have printed the pattern across the grain of the cloth. In Fortuny's fabrics the fibers of the cloth always lie in the same direction, both in the background areas and those printed or woven with metal threads. Rather, they believe that when the cloth was printed, "a screen incised with the waffle pattern was slipped between the stencil and the fabric; or else a brush or roller was used to raise or lay the fibers in an irregular fashion."[36] The latter is the more likely, if we are to believe the tantalizing descriptions of Clara Pravato, one of the last surviving workers at Fortuny's original factory: "The gold and silver powders were poured onto the white fabric, which had previously been prepared with a coating of glue; they were then fixed in place in a chemical bath."[37]

The process by which velvets printed with metallic inks were made to gleam as if with real gold or silver was laborious. After the fabric lengths

ABOVE: a printing proof superimposes purple, green, and yellow stylized lotus flowers and turquoise palmettes on a background of pale *sphenopteris* seaweed, in a wholly original Fortuny design.

RIGHT: a design inspired by a Japanese wave motif drawn from an Edo-period print. This is a green variant of a pattern also printed in silver on red serge.

OPPOSITE: a subtle printed velvet layers bronze-tinted silver on a shimmering pale bronze ground.

MARIANO FORTUNY 165

TOP: this border motif of long-stemmed, luxuriant vegetation, thick at the base and frilly with tiny leaves and peppers, may derive from old colonial printed fabrics.

ABOVE: a chain pattern of blue polygons with intertwined rope knots, probably inspired by an Islamic pavement. The border is of gold vine-leaf clusters.

were washed, dyed "with a flat brush," and printed, they were hung vertically on hooks and the metal areas were "polished." The glue-coated nap of the velvet was raised with scrapers made of cloth pierced with pins and then polished with a marble beater.

One of the most difficult questions is how to categorize Fortuny's decorative motifs. As has been noted, he often re-created or modified antique patterns, drawing upon the inventions of many eras and cultures with an almost proselytic desire to introduce the public to the world's wealth of textile designs.

He always relied on his own taste and sensibility. The mere reproduction or imitation of the past was never his goal. His fabrics were "new interpretations or translations of the antique into another language, so to speak. They were printed, not woven; beautiful designs dating from every period and every style, sometimes reconstructed from fragments of old textiles and sometimes completely original."[38] The art critic Ugo Ojetti, a friend of Fortuny, described them as "silks and silver- and gold-printed velvets with sumptuous leaf patterns taken from Minoan vases or Venetian thistles and pomegranates."[39]

Still, Fortuny's passion for the Renaissance, particularly the Venetian Renaissance, shone through in all he did. To this love we owe his invention of a number of extraordinary worked velvets—complicated textiles with

scores of variants, each richer than the last. There were simple cut and armure velvets (that is, with a decorative motif embossed into the nap) in Quattrocento colors: red, scarlet, crimson, indigo blue, turquoise, violet, dark cherry, Lyon yellow, saffron, and malachite green. The designs were influenced by the floral International Gothic style: sinuous plant stems intertwined in ogival patterns with rows of five-lobed or five-petaled flowers or horizontal stripes with a blossoming thistle, pinecone, or pomegranate in the center. In the Renaissance such velvets had specific names: the pattern of meandering plant motifs was called in Italian *a cammino*, meander-style, or, in French, *velours grillage*, grillwork velvet, because its decorations resemble wrought iron. Fortuny further embellished one of these worked velvets with a background of gold *petite toile* on which was an extraordinary motif of serpentine tree branches (called *a griccia* in the Renaissance) with a thistle flower at the center, outlined by a thin tracery in red velvet.

Patterns proliferated throughout the Cinquecento. They were woven into brocades or frieze velvet (with an uncut looped pile, sheared to form a pattern) or cut into single, double- or triple-cut velvets. Designs woven in silver and gold of varying thicknesses demanded particular skill. Fortuny's interpretation of the patterns of the 1400s and 1500s was aesthetically refined and entirely contemporary.

He was a master of draping, and understood both the weight of a thick velvet and the lightness of a silk. He played with fabric weight, changing the fall of a textile to alter the way it hung. These delicate silks, velvets, and gauzes were extremely fragile and difficult to work with. It takes very little to stain a silk or to flatten or scuff a velvet; yet Fortuny found ways to run his cloth beneath printing rollers and through calendering rollers. He kept the nap fibers falling in the same direction, even when printed with sticky inks, and was able to juggle colors, overprint patterns, and juxtapose techniques without smearing. Among his more brilliant and challenging techniques was that of deliberately discoloring just the top of the velvet nap, in precisely demarcated zones.

A printing proof of ancient Cretan motifs and experimental graphics, including rosettes, knots, vases with stylized handles, geometric friezes, and concentric rings of pearls and petals.

ABOVE: a printing proof tests rosettes, stylized Cretan palmettes, plant forms, waves, and seaweed.

OPPOSITE: Mariano Fortuny, *Henriette*, oil on wood. She wears a Delphos dress and two Knossos silk veils, one wrapped sari-style.

Some of Fortuny's design choices reflected his pride in his Spanish ancestry.[40] He made several fabrics inspired by the brocatelles of the Spanish golden age: one is yellow and red, with rich Spanish-style lace; another is a velvet with tight arabesques and reddish flowers similar to the dress worn by Eleonora of Toledo in the famous portrait by Agnolo Bronzino (see page 150). Other designs, as we have seen in the Knossos scarves, recalled the motifs of the most ancient Mediterranean civilizations. Like the Renaissance textile artists before him, he was inspired by the early Christian designs found in Coptic weavings, by the animals of Byzantine decoration—ruffled parrots and peacocks, fleeing hares and fawns, pelicans, doves, and Eucharistic lambs—by Moorish carvings, tiles, and manuscripts in ritual Qufic and Naskhi script, by medieval floral tapestries, by the jeweled clothes made in Palermo for the eleventh- and twelfth-century Norman kings of Sicily, by the eagles of the Holy Roman Empire. Out of his love for the ornate iconography of sixteenth-century Italy and France came two-handled neoclassical vases adorned with exotic plants, foliage and the little "grotesque" creatures from the hems of Medici tapestries, and heraldic emblems. Robes were embroidered with stitching from the same period: *punto scritto*, or backstitch, cross-stitch, and full stitch in blue, red, and rust on a white background. Fortuny even tackled the elaborate textile designs of the Baroque era, arranged around a central axis and choked with plant and flower motifs; having done that, he tried his hand at the graphic extravagances and mannered meanderings of Rococo.[41]

One of his favorite subjects was the vine, with its leaves, grapes, and arabesques. This he rendered in both naturalistic and stylized form. He never lost his fascination with the Far East, especially the typically Japanese juxtaposition of geometrical and floral elements. Equally appealing to him were the dramatic use in African design of black-and-white contrasts, the strong geometry of Peruvian weaving, and the subtle mysteries of lace. He experimented with designs based on the sun motifs found in Catalonia and Salamanca, on sixteenth-century Italian fishnet patterns, and on virtuoso Venetian rose-point lace. He also used the political emblems of his time, the eagle and the swastika, although he kept the latter discreetly swaddled in flowers.

Although Fortuny first worked with velvet, in his home studio and his handprinting business, when he began producing furnishings for the home he moved on to cotton serge, which he transformed into tapestries, hangings, cushions, carpets, baldachins, pillowcases, and pilaster covers, meant for private homes and mansions, grand hotels and churches. His products were displayed in art galleries, international exhibitions, government buildings, and retail shops.

He found innumerable inventive ways to used his printed silks and velvets. One of the most distinctive was his line of lampshades made of transparent silk organza, printed in gold with oriental flower patterns, arabesques, and dragons, and stretched over thin frames. The

Scheherazade model was round and convex, with a protruding point at the center like a Saracen shield; other models were spiral-shaped, like a broad or narrow snail shell; or chalice-shaped like the old *cesendeli* oil lamps that were hung before sacred images in churches; or polyhedral, like Chinese lanterns. They came in various sizes and some were made up of several separate parts. Most were embellished with fine silk cords, tassels, and beads.

The Dresses

Fortuny himself said that his "industry had begun with silk shawls and moved to dresses." By this he meant that he had made his name with the ladies' garments that at first were too radical for the fashions of the day. As they found their way into the wardrobes of fashionable women throughout Europe over the next quarter-century, they gradually transformed fashion itself. These were the Art Nouveau years: the era of floral decoration, "aesthetic" clothes, and the Wiener Werkstätte. A certain class of emancipated woman had already given up *bustiers* and stays, which artificially modified the lines of the body by exaggerating curves and cinching the waist. Ancient Greece was in fashion; the couturiers Jacques Doucet, Paul Poiret, and Fortuny launched their versions of the neoclassical style almost simultaneously.

Mariano Fortuny dresses were so extraordinary that for decades they remained the possession of the international elite. They were quite

TOP AND ABOVE: the classic Fortuny overblouse in transparent ocher silk gauze, printed in silver with plant motifs and worn next to the skin.

OPPOSITE: an overblouse in ocher silk gauze, printed in silver with plant motifs, is worn over a short-sleeved ivory-colored Delphos in silk satin. This piece is now in the Museo Fortuny.

simply legendary. The most famous design was the Delphos, a pleated tunic inspired by a robe seen on male and female Greek statues from the sixth and fifth centuries B.C., as well as on figures on painted vases. The specific models were the *Kore of Euthidikos*, the *Kore of Samos*, and the *Charioteer* of Delphi. In essence the Delphos consisted of a sheath simply constructed from four or five pieces of material 95 centimeters (37½ inches) wide. The material was originally a silk taffeta, later changed to a very light Asian satin.

In its 1909 patent, the Delphos was described as "a sheath open at both ends, gathered at the top in such a way as to form a neck opening at the center; with two openings for the arms on either side, two openings with hems tightened by laces along the arms, and slanting draw hems for adjusting the sleeves."[42] The sleeves might be short, long, or nonexistent. The patent also makes it clear that the dress could be made of either smooth or pleated cloth, although it was the pleated version that caused a sensation.

Fortuny's celebrated accordion pleat consisted of very tight vertical sequences of folds; there are between 430 and 450 pleats per fabric width. It was made "in the simplest way, by hand." To start with, this was done by "slipping the wet fabric through the hand and squeezing it in such a way as to crumple it lengthwise."[43] This did not satisfy the master, however, and he soon revived a technique used in Renaissance Venice for pleating church vestments. In this method each pleat was formed with the thumbnail and squeezed tightly against its neighbor

TOP: a silk-taffeta fabric printed with fourth-century Coptic motifs and tenth-century Persian and Safavid designs.

ABOVE: a double textile of lace-printed threaded voile over silk velvet. The two panels are threaded together with ribbons strung with *pâte-de-verre* beads.

OPPOSITE: a two-color Delphos with red beads.

with the other hand.[44] Once the pleats had been set with starch or with a glue made of egg white, the textile was ironed. Sometime after 1925 Fortuny developed an industrial technique that mimicked this. The precise process is not clearly described, but the fabric was laid between two pieces of folded cardboard, pressed between two heavy pieces of wood, rolled onto cylinders, and finally placed in a steam oven at a temperature between 100° and 120°C (212°– 248°F). This produced a dependably uniform pleat; apparently the method was abandoned later, when Fortuny dresses did not have the same degree of evenness. Clara Pravato recalls (without revealing any secrets) that Henriette was in charge of the pleating and the couture work in general. To pleat a single Delphos took two hours, and "much longer to remove all the glue with your fingers" and make the satin supple again. It took eight hours in all to make a sleeveless Delphos. In 1909 Mariano Fortuny also patented a tool made of "nickel-plated copper, or porcelain tubes," heated electrically, for making "a pleated, wave-textured material with the look of locks of hair."[45]

The Delphos envelops the body in a clinging fashion; underwear is unthinkable. It does not so much cover the body as reveal its shape to advantage. The Fortuny pleat does not wrinkle or lose its shape, but expands slightly over convex curves while remaining compact in other areas, thus creating alluring zones of light and shadow. A body need not be perfect or youthful to look fascinating in this garment, which seems to have a life of its own. Moreover, the

Delphos is practical: it was well ahead of its time in that it was made in a single size in both length and width. It can be bloused at the waist if it is too long, or left to trail gracefully around the feet, like a flower. The cloth is plainly colored and has no ornament apart from silk drawstrings and a few small beads of Murano glass, specially made by the Conterie Veneziane and used sparingly for lacing and buttoning.[46]

A variant known as the Peplos consisted of a simple tunic like an Egyptian *kalasiris* and a short overblouse made of four or six strips of fabric ending in a pronounced point, with the hem weighted by beads of matching colors, and closed by cylindrical *pâte-de-verre* buttons. The border could be asymmetrical and longer at the hips, or longer in back. It could be sleeveless; if there were sleeves they could be short, long, full, or tight to the wrist; the neckline could be round, triangular, or boat-neck. The preferred colors were cream, pearl gray, sky blue, turquoise, indigo, amethyst, sage green, jade green, coral red, crimson, powder pink, salmon orange, and a creamy yellow called zabaglione (a crème anglaise dessert). Sometimes two or three shades were juxtaposed, and occasionally the overblouse was a second color, or part of the tunic was made in another shade, to look as though it had been sewn on.

Fortuny's plissé garments were sold in a special box, and came twisted and rolled up like a snake. The buyer was advised not to hang the dress, but to store it like this, in order to preserve

ABOVE: the ancient Ionian Greek *Kore of Samos*, 570 BC, now in the Musée du Louvre, Paris, wears a *peplos* with an uneven hem.

OPPOSITE: detail of a pleated silk-taffeta tunic edged with beads and worn over a pleated taffeta skirt. The warm tones echo the colors of a Venetian *terrazzo* floor such as that in Fortuny's grand salon (see pages 50–51).

MARIANO FORTUNY

the pleats. (The modern reproductions of Fortuny clothes are still sold this way.) In a 1910 advertising flyer the Delphos was described as "unaffected by time or the seasons"; in addition to the "pleated, Orphic dresses," coats, mantillas, tabards, *abajas, sephis,* caftans, dolmans, and kimonos were also mentioned.[47] One of Fortuny's most successful dresses was inspired by a medieval robe: the Eleonora (named in honor of Eleonora Duse) was made up of two pieces of printed velvet falling straight at front and back, and attached on the sides to panels of pleated satin. Among Fortuny's capes, the most memorable were those with triangular hoods, inspired by the Venetian Renaissance paintings of Vittore Carpaccio and the woodcuts of costume and dress published in the sixteenth century by Cesare Vecellio. He also made cloaks based on the North African burnous and Moroccan *jellaba*. Another signature Fortuny garment is a transparent underdress, usually composed of four rectangular panels of thin muslin (light or dark in color) printed in black with carefully placed Coptic motifs or Renaissance patterns, isolated from their original decorative context and enlarged or reduced like pure graphics.

A variant in printed silk crepe with trapezoidal panels has a curious batlike outline. This copies the shape of the ancient Coptic tunic, with its traditional embroidered bands, called *clavi*, and also has something of the shape of the eighteenth-century Venetian double pelerine, a short cape of voile trimmed with lace.

There were pleated-silk bags to match the dresses, usually decorated with one or two glass pearls and closed with a drawstring. The firm also made liturgical vestments, particularly for churches in Spain, and costumes for the stage.

Eccentrics, divas, intellectuals, and aristocrats flocked to buy Fortuny's clothes, which spoke of refined extravagance while exalting the personality of the wearer. Celebrities gave him their seal of approval—among many others, the actors Sarah Bernhardt, Eleonora Duse, Lillian and Dorothy Gish, Orson Welles, Natasha Rambova, and Dolores del Rio; the dancers Isadora Duncan (who invariably danced in a Fortuny Delphos, belted at the hip with a printed Knossos) and Ruth St. Denis; the photographers Man Ray, Nadar, Alfred Stieglitz, and Cecil Beaton; the writers Marcel Proust and Gabriele d'Annunzio; Clementine Churchill, Baroness

ABOVE: a cushion covered in a silver-printed silk velvet based on a design from fourteenth-century Lucca.

OPPOSITE: another fourteenth-century Lucchese textile was the inspiration for this silk velvet dyed in tones of blue, white, and rose, and overprinted with silver.

Rothschild, Mme Condé Nast, and innumerable other leaders of society. In 1913 the *grande dame* known as La Casati stormed the Fortuny workshop at Palazzo Pesaro-Orfei in company with the theater designer Léon Bakst and guests from a ball she had organized on the Piazza San Marco.

Vogue USA published full accounts of Fortuny's collections until 1917. He himself left abundant records of his clothes, which he photographed himself. At first he posed them on tailor's dummies, nineteenth-century style, then on live models with pre-Raphaelite hairstyles and expressions.

TOP LEFT AND RIGHT: two cotton textiles printed in imitation of velvet with graceful grapevine motifs.

ABOVE: grapevine patterns in antique church vestments.

RIGHT: an indigo-dyed silk velvet, printed with silver and gold grapevines.

OPPOSITE: church vestments printed with silver and gold in imitation of cut and embroidered velvet.

At the height of his career he had shops and agencies in Paris, London, Berlin, Zurich, and New York.

Yet Fortuny was an introvert all his life, and the tendency increased as he grew older.[48] He had few close friends, among them the Hohenlohes and of course d'Annunzio, who nicknamed him Marianaccio (wicked Mariano) and tried to take advantage of their friendship to get free set and costume designs for his plays. In Venice Fortuny was known by the honorific title Commendatore, and treated as a kind

of modern Leonardo da Vinci. But he was private and discreet; no mention of him was ever made in contemporary gossip columns, and Maria Damerini, who recounted in excruciating detail the life and leisure of Venetian high society between 1920 and 1940, had nothing to say about him beyond the fact that he was "haughty by nature" and "courteous to a fault."[49]

There is no doubt that in his youth he had a great weakness for women. Stories are still told of *rendezvous galants* arranged with the complicity of his friend Giancarlo Stucky. These were staged in the style of the Thousand and One Nights. Stucky would decorate the magnificent portico of Palazzo Grassi like the tent of an Arab sheikh, and the ladies invited for the evening were dressed in diaphanous clothes that transformed them into odalisques. Despite these extravagances, however, he seems to have settled down after he married Henriette, and to have maintained a partnership with her that was enduring and creative for both.

In the early 1930s he returned to Greece with his wife, perhaps in search of fresh inspiration. We have photographs of this trip; one shows us a thickset figure in dark trousers that are slightly baggy at the knees.[50] He wears a black ribbon for his recently dead mother on the lapel of his white duster-coat, a panama hat on his head, a cane in his hand. He looks bemused, lost, perhaps, in contemplation of the past.

OPPOSITE: a bishop's cope designed by Fortuny of gold-printed scarlet silk velvet, with patterns adapted from fifteenth-century church vestments.

TOP AND ABOVE: an immense mortuary pall (6 x 4 meters, or 19¾ x 13 feet) and other catafalque cloths in black velvet, printed with silver and gold, were commissioned from Fortuny by the Duchess of Lerma for her own funeral and given to the parish after her death. The largest cloth weighed 28.34 kilos (more than 62 pounds).

MARIANO FORTUNY 181

ABOVE AND BELOW: two Fortuny labels, both post-1909.

OPPOSITE: two studies for a theater costume.

Notes

1. Mario Praz, *La Filosofia dell'arredamento*, Milan: Longanesi, 1990, p. 66. He quotes a text by Alfred de Musset from *Les confessions d'un enfant du siècle* (1836): "The apartments of the wealthy are like *cabinets de curiosité*: antique, Gothic, Renaissance, Louis XIII, all jumbled up together. We have something from every century except our own . . . eclecticism is our taste."
2. Paolo Peri, "La Trama della sua vita," in Peri et al., *Fortuny nella Belle Epoque*, Milan: Electa, 1984, p. 61.
3. Claudio Franzini, "L'opus magnum' di un hidalgo veneziano: Biografia di Mariano Fortuny y Madrazo," in *Mariano Fortuny*, exh. cat., Venice: Marsilio, 1999, p. 59. Speaking of Fortuny's mother and sister, Franzini reports that "in 1915, hard-pressed by mortgages on Palazzo Martinengo, they were obliged to sell part of their collection of old fabrics."
4. Marcello Brusegan, *Il Fondo Mariutti-Fortuny della Biblioteca Nazionale Marciana*, 1997, p. 193. A document in the Mariutti-Fortuny archives at the Biblioteca Nazionale Marciana, Venice, signed by Fortuny, lists 853 antique fabrics.
5. Doretta Davanzo Poli, *Seta d'oro*, Venice: Arsenale, 1997.
6. Giovanni and Rosalia Fanelli, *Il Disegno moderno: disegno, moda, architettura, 1890–1940*, Florence: Vallecchi, 1976, pp. 23–28.
7. Davanzo Poli, *Seta d'oro*, pp. xvii, 200.
8. Praz, *La Filosofia dell'arredamento*, p. 21.
9. Giorgio Sangiorgi, *Contributi allo studio dell'arte tessile*, Rome: Bestetti & Tuminelli, n.d., p. 19.
10. Silvio Fuso and Sandro Mescola, *Immagini e materiali del laboratorio Fortuny*, Venice: Marsilio, 1978, p. 23.
11. Marco Tosa, in *Mariano Fortuny*, exh. cat., 1999, p. 253, entry no. 4.
12. Franzini, "L'opus magnum,'" in *Mariano Fortuny*, exh. cat., pp. 59, 61, 64: "In a letter to the Comtesse de Béarn in May 1915, he writes: 'I have canceled everything here—all the effort and difficulty has fallen on my shoulders and the atmosphere of uncertainty and anxiety, which increases daily, is unbearable. . . . In the last few weeks the market in Paris has vanished like a puff of smoke, and in London it is heading the same way.' . . . The crisis on the New York stock exchange had serious repercussions on Mariano's business . . . the machines were impounded and the factory was closed down. . . . In 1936, the self-sufficiency decrees imposed by the fascist government created a serious obstacle to the importation of raw materials from the cluster of nations opposed to the regime—materials that were indispensable to production at the Giudecca factory." It was at this juncture that Mariano sold the Goya drawings left to him by his grandfather to the Metropolitan Museum of Art in New York.
13. Guillermo de Osma, *Fortuny: The Life and Work of Mariano Fortuny*, London: Aurum Press, 1980, p. 132.
14. Franzini, "L'opus magnum,'" in *Mariano Fortuny*, exh. cat., pp. 55–56.
15. There are a few photographs that show the use of wooden stamps: in one of them Henriette is seen using a brush to lay colors on a wooden stamp engraved with a Belliniesque palm motif; see Fuso and Mescola, *Immagini e materiali del laboratorio Fortuny*, fig. 50.
16. Patent no. 427,307, applied for on May 24, 1910, Paris, Imprimerie Nationale; published in Fuso and Mescola, *Immagini e materiali del laboratorio Fortuny*, pp. 23–24.
17. Archivio della Camera di Commercio, Industria e Artigianato di Venezia (hereafter ACCIAV), copy of the limited partnership contract, notarized registration no. 40023/1746 (December 30, 1911, notary Francesco Da Chiurlotto).
18. Franzini, "L'opus magnum,'" p. 56 and n. 39; article by Henri Lavedan in *L'Illustration*, April 22, 1911 and translated by Bice Tittoni, vice-president of the Industrie Femminili Italiane, which organized the Italian section of the exhibition.
19. ACCIAV, declaration of company name no. 95046, March 1916. According to the signed document, Fortuny was still residing at Palazzo Martinengo, but his workplace was Palazzo Pesaro-Orfei.
20. ACCIAV, industry 2131, registration of a private company, March 16, 1925. Added to the document later, in red, were the words: "date 15/5/38 ajouté . . . à Paris, rue Pierre Charron 67, depot et vente de tissus imprimés artistiques." Another document, dated January 25, 1942 and signed Mariano Fortuny, states that "given the present state of affairs and because of the immense difficulties in maintaining communications, the said premises no longer exist as a depot. Mme Martin, formerly the shop manager, now assumes the responsibilities of a representative only." Clara Pravato, who worked with Henriette Fortuny for more than forty years, remembers that there were never more than sixty employees.
21. ACCIAV, registration of notice of cessation of business no. 60,118. In the same file is a copy of Mariano Fortuny's original will, which states: "I bequeath to my wife everything I possess, whether inherited, acquired, or manufactured, both movables and real estate, without exception."
22. ACCIAV, registration of a limited company no. 17,198, August 22, 1920.
23. Davanzo Poli, *Seta d'oro*, p. xvi: this document is in the Mariutti-Fortuny archive at the Biblioteca Nazionale Marciana, Venice.

24. ACCIAV, Società Anonima Fortuny, minutes of general meeting, September 30, 1927.
25. ACCIAV, telegram sent by "Soc. An. Fortuny" to the Consiglio Provinciale dell'Economia Corporativa di Venezia, September 12, 1935/XIII: "The said company hereby declares that as a temporary measure it needs to import about 2,500 meters of white cotton, ordered from Tootal Broadhurst Co., Manchester, England, to be converted into printed fabrics ordered by A. H. Lee and Sons, Madison Avenue, New York, to whom the latter must be delivered in the course of the year."
26. ACCIAV, minutes of shareholders' meeting of the Società Anonima Fortuny, September 30, 1936/XIV.
27. ACCIAV, minutes of shareholders' meeting of the Società Anonima Fortuny, October 16, 1939, report of M. Fortuny: "In the period between July 1, 1938, and June 30, 1939, production at the Giudecca plant continued on a regular basis, though volume was down on previous years. Turnover fell from £97,078.55 for 1937–1938 to £82,366.45 for 1938–1939. This falling off should not surprise you, given that our product is almost exclusively intended for export, and this becomes daily more difficult on account of monetary difficulties, customs barriers, and the unique conditions prevailing abroad. Our company, in order to maintain sales internationally, has not hesitated to reduce its prices, sometimes merely to gain publicity; but while income in foreign currencies is an undoubted advantage for the Italian economy, especially at the present time, revenues that only occasionally yield a profit have had a damaging and disturbing effect on our accounts. In addition to this, general expenses have increased considerably, largely because of the tax burdens imposed on the company, and this despite the obviously precarious trading climate and a complete absence of taxable income. Today, export is rendered even more difficult because of the state of war existing between certain European states and because of international relations, which grow ever more strained and uncertain. We have therefore been obliged, while awaiting better times, which we hope will come soon, to cut back production substantially; and in consequence we must now lay off a number of staff."

ACCIAV, minutes of shareholders' meeting of the Società Anonima Fortuny, October 16, 1940, report of M. Fortuny: "In the period July 1, 1939–June 30, 1940, production at the Giudecca factory dwindled to almost nothing and has now completely ceased. The war between certain European states, which began in September 1939, has made the export of our products almost impossible. Moreover, during the month of June, after Italy's entry into the war, we lost all our credit with our French and English clients. At the present time, production at the factory has ceased because our products—or nearly all of them—were formerly sent to France, the United States, England, and other countries which for obvious reasons can no longer import them."

ACCIAV, minutes of shareholders' meeting of the Società Anonima Fortuny, October 25, 1941, report of sole administrator M. Mariano Fortuny: "In the fall of 1940, raw materials were lacking and the volume of orders fell, particularly orders from abroad. I therefore stopped all productive activity, confining myself to recovering old debts and maintaining stock. In March 1941, as soon as the current administrative measures had been taken, I was obliged to lay off all remaining personnel. It has not been possible to keep the factory open."
28. ACCIAV, minutes of shareholders' meeting of the Società Anonima Fortuny, in liquidation, November 16, 1946, report of the sole liquidator, M. Mariano Fortuny y Madrazo: "During the previous accounting periods, I have sold, transferred, or recovered everything I could for the business. All that remains to be disposed of is the factory on the Giudecca, but it seems to me that the right moment for this has not yet arrived, given that the factory has no more significant work and that it is no longer possible to resume anything like its former production without incurring considerable expense in repairs, adaptation, and renovation of the old machinery. Despite all these difficulties, I have continued to bear the costs of maintenance, wishing to keep the factory in a satisfactory state; as you know, it was seriously damaged by bombs in March 1945. In this way I hope to avoid further rapid deterioration of its industrial structure."
29. ACCIAV, document no. 672.
30. Nicola Randolfi, *Trasformazione urbana e produzione industriale in Venezia città industriale*, exh. cat., Venice: Marsilio, 1980, p. 110: "At the present time, Fortuny is one of the factories still operating in Venice. It has thirty employees, of whom seventeen are women, and its products are in demand throughout the world."
31. Gabriel Vial and Odile Valensot, "Procédés et techniques," in Guillermo de Osma, *Mariano Fortuny—Venise*, Lyon: Sézanne, 1980, p. 26. Clara Pravato confirms the work on white cloth.
32. Ibid.
33. Ibid.
34. Patent no 419,269, applied for on October 21, 1909, Paris, Imprimerie Nationale; pp. 1–2.
35. Vial and Valensot, "Procédés et techniques," 1980, pp. 26–27
36. Ibid.
37. Recorded interview with Clara Pravato by Liselotte Höhs, 1996, updated February 2000.
38. Henri Lavedan, *Société Anonyme Fortuny—Venise*, Venice, n.d. (1919), p. 1; Davanzo Poli, *Seta d'oro*, pp. xvi–xvii.
39. Cesare Meano, "Fortuny (Fabrics)," article in *Commentario Dizionario italiano della moda*, Turin: Ente Nazionale Moda, 1936, p. 165.
40. With a signed declaration he retained his Spanish citizenship until his death, as is confirmed by two documents issued by the Spanish Embassy, now in the ACCIAV.
41. See G. Marangoni, *Enciclopedia delle mode nelle arti decorative italiane*, vol. 5: *Le Stoffe d'arte*, Milan: Ceschina, 1928, plate 48.
42. Patent no. 408,629 applied for on November 4, 1909, Paris, Imprimerie Nationale, 1910.
43. Patent no. 414,119, applied for on June 10, 1909 Paris, Imprimerie Nationale, 1910 p. 1, ll. 24–29.
44. A former nun still does this work at the Istituto delle Figlie di S. Giuseppe di Rivalba, S. Marcuola, Venice. I myself saw her at work on the restoration of a surplice in 1994.
45. Patent no. 414,119 applied for on June 10, 1909, Imprimerie Nationale, 1910, p. 1, ll. 1–4.
Clara Pravato states that this model was not commercially successful.
46. Cf. Archivio della Società Veneziana Conterie, Murano, Venice, register of current accounts for 1915–22 and 1920–25 (segn. A.V. 5, A.V. 8): this contains orders for beads placed by Mariano Fortuny in the following sums: in 1917 for £202; in 1918 for £188.50; in 1919 for £239.40; in 1921 for £505.75; in April 1923 for £105.83; in August 1923 for £344.931; and in June–September 1924 for £621.45.
47. Doretta Davanzo Poli, "Fortuny e il suo ideale di classicità," in G. Butazzi and A. Mottola Molfino, *Classicismo e libertà*, Novara: De Agostini, 1992, p. 49.
48. Ada Gandolfo Ongaro of the Università degli Studi di Venezia was a neighbor of Fortuny's as a young child in the 1920s. She remembers visiting his house and seeing him peer out from behind the rich draperies, showing only a handsome, dark-skinned face with a prematurely white beard. As she tried desperately to hide behind her father, he unsmilingly proffered a candy.
49. Maria Damerini, *Gli Ultimi anni del Leonar: Venezia, 1929–40*, Padua: Il Poligrafo, 1988, p. 83.
50. Clara Pravato recalls that Mariano Fortuny's favorite outfit was a Spanish cloak and a singular design of trouser, narrow at the ankles and thighs like a pair of waders, and slightly baggy at the knees, Zouave fashion.

RIGHT: Mariano Fortuny, *Self-Portrait*, 1947.

OPPOSITE, ABOVE: Mariano Fortuny, *Portrait of Maria Luisa*, 1893.

OPPOSITE, BELOW: Mariano Fortuny, *Portrait of Henriette in a Venetian Shawl*, oil on canvas.

Chronology

1871: May 11, birth of Mariano Fortuny y Madrazo in Granada, Spain, son of Mariano Fortuny y Marsal and Cecilia de Madrazo.

1875: November 21, Fortuny's father dies in Rome and the family moves to Paris to be near Cecilia's father and brother, both painters. The family's collection of antique textiles and art is sold.

1876–85: artistic training of the young Mariano in the Paris studio of the painter Benjamin Constant. He spends time in the company of the painters Alfred Tissot, Paul Baudry, Emmanuel Frémiet, Giovanni Boldini, Alfred Stevens, Jean-Léon Gérome, Ernest Meissonnier, Rogelio Egusquiza.

1889: the family moves to Palazzo Martinengo in Venice and begins collecting antique textiles again.

1896: Fortuny wins a gold medal at the Munich Exhibition for his Wagnerian painting *The Young Ladies in Bloom*.

1897: he meets his companion, later wife, Henriette Negrin, in Paris.

1899: he directs a production of Gilbert and Sullivan's operetta *The Mikado* at Palazzo Albrizzi, Venice. Gabriele d'Annunzio commissions stage designs for his *Francesca da Rimini* from Fortuny; the project is completed by Angelo Rovescalli.

1899–1900: Fortuny moves to Palazzo Pesaro-Orfei in Venice. He designs sets for *Tristan and Isolde* at La Scala, Milan, and begins to design new concepts of stage architecture and lighting.

1901: Fortuny moves to Paris, first to rue Washington and subsequently to a larger studio on boulevard Berthier, where he perfects his concept of the Fortuny dome theater and indirect stage lighting.

April 21, in Paris, Fortuny patents a system for indirect stage lighting.

1901–3: Fortuny further develops his theater dome, which is much admired by Sarah Bernhardt, the Coquelin brothers, and the Wagnerian director Friedrich Kranich.

1902: January 20, Fortuny's first indirectly lighted mobile dome theater debuts on rue Saint-Charles in Paris. Later in the year Henriette Negrin joins him in Venice.

1903: Fortuny meets Adolphe Appia and the Comtesse de Béarn.

1904: Mme de Béarn commissions him to redecorate her private theater on rue Saint-Dominique. Fortuny prepares a stage-set design for Appia of Act II of *Die Walkürie* by Richard Wagner.

1906: March 29, a ballet by Charles-Marie Widor at the Comtesse de Béarn's theater inaugurates the Fortuny stage system.

In May, together with the German company AEG, Fortuny founds the Beleuchtung System Fortuny Gmbh in Berlin to construct his dome and its lighting system.

1907: installation of a mobile collapsible dome at the Kroll Theater in Berlin. In collaboration with AEG, installation of several domes in German theaters: in 1910 at the Schauspielhaus, Dresden; in 1912 at the Deutsches Operhaus, Charlottenburg; in 1914 at the Neuefreie Volsbuhne, Berlin; in 1919 at the Schauspielhaus, Berlin.

Meeting with Max Reinhardt and Hugo von Hofmannsthal. Designs sets for a Venetian Ball for an exhibition in London.

In December, in Venice, Fortuny starts printing fabrics with Henriette Negrin.

1908: he designs lighting for the foyer of the Palais Garnier Opera, Paris.

1909: in June, October, and November he patents a type of pleated fabric, a fabric printing process, and a women's garment, later named the Delphos.

1910: June 11, in Paris, Fortuny patents systems for dyeing and pleating fabrics.

1911: Fortuny exhibits his printed fabrics at the Exposition Internationale des Arts Décoratifs in Paris.

December 30, he establishes his first, privately owned, textile firm, with his mother as partner.

1912: Fortuny founds the Théâtre des Fêtes in Paris with Gabriele d'Annunzio and the architect L. Hess. He works on set designs for the landmark Ballets Russes production of *The Blue God*, based on a text by Jean Cocteau and Frederigo de Madrazo, with costumes by Léon Bakst.

1915: he is appointed honorary vice-consul of Spain in Venice. During World War I, he joins the committee for the preservation of Venetian works of art. Part of the family's textile collection is sold.

1916: February 15, the original Fortuny company is dissolved and reconstituted with Fortuny as sole owner.

1919: with his friend the manufacturer Giancarlo Stucky, Fortuny founds the Società Anonima Fortuny, a publicly held joint-stock company to create printed fabrics, with a factory on the Giudecca, Venice.

1919–20: the height of Fortuny's success as an interior decorator and fashion designer. He opens a shop on boulevard Haussmann in Paris.

1922: in collaboration with the Leonardo da Vinci Society, Fortuny sets up his mobile collapsible dome at La Scala, Milan.

1924: Fortuny fabrics are hung in exhibition rooms at Monza and in the Spanish pavilion at the Venice Biennale. Thereafter Fortuny participates as a painter in all the Biennales until 1942.

1929: in collaboration with the Leonardo da Vinci Society, Fortuny creates a mobile collapsible dome for Giovacchino Forzano's Carro di Tespi traveling theater in Italy; he installs his lighting system at the Teatro Real in Madrid; he opens a retail shop in New York.

1931: he designs stage sets for Wagner's *Die Meistersinger* in Rome.

1931–32: he designs lighting for the Exposition d'Art Français in London.

1937: he designs lighting for the Scuola Grande di San Rocco in Venice. In collaboration with Nicolas Benoist and Mario Cito Filomarino, he directs and

designs costumes for the opera *I Trionfi* at the Castello Sforzesco in Milan.
1941: during World War II, Fortuny's textile manufacturing company fails and is closed.
1944: he creates set designs for Manuel de Falla's *La Vita Breve* at La Scala, Milan.
1949: Mariano Fortuny dies in Venice. His wife continues the company until 1951, selling it in 1952.
1951: Henriette Fortuny founds Tessuti Artistici Fortuny, which produces Fortuny fabric designs until her death in 1965.
1994: Elsie Kruse McNeill Lee reopens the firm and Fortuny designs are once again produced.

Bibliography

Adolphe Appia, 1862–1928: Acteur, espace, lumière. Zurich: Pro Helvertia, 1979.

Barberis, Maurizio; Franzini, Claudio; Fuso, Silvio; and Tosa, Marco. *Mariano Fortuny.* Exh. cat., Museo Fortuny. Venice: Marsilio, 1999.

Brusegan, Marcello. *Il Fondo Mariutti-Fortuny della Biblioteca Nazionale Marciana,* 1997.

Corriere della Sera, June 20, 1929.

Damerini, Gino. *D'Annunzio e Venezia.* Milan: Mondadori, 1943.

Davanzo Poli, Doretta. *La Collezione Cini dei musei civici Veneziani: tessuti antichi.* Venice: Museo Correr, 1991.

———. *Seta d'oro: La Collezione tessile di Mariano Fortuny.* Venice: Arsenale, 1997.

Davanzo Poli, Doretta, and Moronato, Stefania. *Le Stoffe dei veneziani,* Venice: Albrizzi, 1994.

Davillier, Charles. *Fortuny: Sa vie, son oeuvre, sa correspondence.* Paris, 1875.

Emporium, August 1916.

Fanelli, Giovanni and Rosalia. *Il Tessuto Art Decò e Anni Trenta: Disegno, moda, architettura.* Florence: Cantini, 1986.

———. *Il Tessuto Art Nouveau: Disegno, moda, architettura.* Florence: Cantini, 1986.

———. *Il Disegno moderno: Disegno, moda, architettura, 1890–1940.* Florence: Vallecchi, 1976.

Fortuny e Caramba: La moda a teatro, Costumi di scena 1906–1936, Exh. cat., Venice: Marsilio, 1987.

Fortuny y Madrazo, Mariano. *Fortuny 1838–1874,* Bologna, 1933.

Fuso, Silvio, and Mescola, Sandro. *Immagini e materiali del laboratorio Fortuny.* Venice: Marsilio, 1988.

Hartley, L. P. *Eustace and Hilda.* London: Putnam, 1947.

Heuzey, Léon. *Histoire du costume dans l'antiquité antique.* Paris, 1922.

Immagini e materiali del laboratorio Fortuny. Venice: Marsilio, 1978.

Jullian, Philippe. *Gabriele d'Annunzio.* Paris: Fayard, 1971.

Lavedan, Henri. *Société Anonyme Fortuny.* Venice, n.d. (1919).

McCarthy, Mary. *The Group.* New York: New American Library, 1954.

Le Ménestrel, April 15, 1906.

Morand, Paul. *Venises.* Paris: Gallimard, 1971.

Newton, Helmut. Unpublished interview with José Alvarez, Paris, 1979.

Osma, Guillermo de. *Fortuny: The Life and Work of Mariano Fortuny.* London: Aurum, 1980.

Peri, Paolo. *Tessuti del Rinascimento nei repertori ornamentali.* Florence: Museo Nazionale del Bargello, 1994.

Peri, Paolo, and Fanelli, Rosalia Bonito. *Tessuti italiani del rinascimento: Collezioni Franchetti e Carrand.* Florence: Museo Nazionale del Bargello, 1981.

Peri, Paolo, et al., *Fortuny nella Belle Epoque,* Milan: Electa, 1984.

Proust, Marcel. *A la recherche du temps perdu* (*In Search of Lost Time*). 1913–27. Paris: Pléiade, 1954.

Régnier, Henri de. *L'Altana, ou la vie vénitienne.* Paris, 1927.

Sangiorgi, Giorgio. *Contributi allo studio dell'arte tessile,* Rome: Bestetti & Tuminelli, n.d.

Schure, Edouard. *Wagner: Son oeuvre et son idée.* Paris: Perrin, 1914.

Todisco, Alfredo. *La Stampa,* September 27, 1957; May 2, 1958.

Yriarte, Charles. *Fortuny,* Paris: Rouam, 1886.

RIGHT: Mariano Fortuny, *Still Life in the Studio*, 1939.

BELOW RIGHT: Mariano Fortuny, *Portrait of a Woman*, pencil on paper.

Index

Appia, Adolphe
 on theater lighting, 129
 work with Fortuny, 127, 129
Art Nouveau years, 171
artistic preferences, 30, 53
batwing dress, 84, 107
birthplace, 9
burnous style, 65, 80
caftans, 79
capes
 most memorable, 176
 printed velvet, 153
 styles, 67, 84, 140
coats, 84
commercial factory, 65
companies after Fortuny's death, 162
contemporary art, 23
costume designs, 124
couture shop, New York, 83
de Madrazo, Cecilia, *see* Fortuny, Cecilia
decorative motifs, 166
Delphos dress
 Lillian Gish in, 96
 Liselotte Höhs in, 113
 Condé Nash in, 104
 Selma Schubert in, 99
 creation of, 172
 design, 104, 171
 detail, 117
 dimensions, 175
 inspiration for, 176
 pâte-de-verre beading, 95, 114
 patent for, 171
 pleats, 95, 96
 styles, 79, 80, 83, 99, 107, 108, 118, 172
 success, 104
design choices, 168
design label, 79, 114, 182
dimmer switch invention, 123, 125
dome, *see* Fortuny dome
doublet
 Italian Renaissance pattern, 53
 used in *Othello*, 56
dress, medieval-style, 71
dresses
 gowns, 63
 legendary designs, 171
Dubroni camera, 42
Duncan, Isadora, 104
Edwardian dress, 110
electricity
 effect on the theater, 125
 inventions using, 123, 125
 work with Adolphe Appia, 129
fabric designs
 inspiration for, 154, 155
 for interior decoration, 83
 new interpretations, 166
 preferred cloth, 162
 printing methods, 163
 types, 143–144, 147, 148, 156–157, 159, 161, 163
fabrics
 Cretan, 151, 154
 dyes, 83, 162
 Italian Renaissance style, 153
 Oriental gauze, 80
 pleated silk, 58
 printed silk-velvets, 58, 140
 printing techniques, 163, 165, 166
 source of inspiration, 151
 success with, 156
 tapestry, 163
fashion designs
 displayed collection, 71
 jellaba, 63, 92
 kimono, 63
 Marcel Proust novels and, 63–64, 71, 92
 medieval-style dress, 63
 modern reproductions, 176
 patrons of, 176, 178
 printed velvet cape, 63
 stage use, 79–80
 wearers of, 176
financial difficulties, 154–155, 161–162
Fortuny, Cecilia, 12, 14
 collector of fabrics, 13
 mother, 11–12, 17
Fortuny dome
 applications, 130
 conception, 125–126
 construction of, 131–132
 design sketch, 127
 development, 126–127
 success of, 129

186 MARIANO FORTUNY

technical description, 130
The Fortuny Dress
　box and storage, 175
　fabrics and experience of, 118
Fortuny, Henriette, 46, 162
Fortuny look, 54
Fortuny, Mariano
　artistic expression, 30, 53
　artistic inspiration, 139, 143, 150
　business relationships, 131–132
　career, 178
　clothing designer, 54
　companies, 160–161
　descriptive terms for, 139
　design choices, 168
　early life, 9
　etchings, 19
　father, 9–10
　homes, 13
　influences, 17
　inspiration, 166
　interior decorator, 54
　life chronology, 184–185
　mother, 11–12, 14, 17
　in Paris, 125, 131
　postwar influence in Europe, 117
　private life, 178, 181
　self-portrait, 14, 24, 57, 184
　sister, 14
　successes, 54, 63
　teachers, 17
　the theater and, 123, 125–127
　youth, 17, 23
Fortuny y Marsal, Mariano
　artistic inspirations, 10
　career, 10, 12
　collector, 10, 11
　death, 12
　family, 12–13
　marriage, 11–12
　in Paris, 11
　Rome studio, 9, 11
　wartime experience, 10, 11
furniture designs, 33, 37
Gish, Lillian, 96
Giudecca factory, 54, 55
gowns, 63
Granada, Spain, 9
Höhs, Liselotte, 113
interior decoration, 54
inventions
　dimmer switch, 123, 125
　lighting dome, 125–129
　photographic paper, 54
　pleating machine, 113
　polychrome printing, 162–163

ABOVE AND RIGHT: Mariano and Henriette Fortuny in Egypt and Greece.

OVERLEAF: Campo SS. Giovanni e Paolo, Venice, photographed by Fortuny.

Italian Renaissance style, 53, 153
jellaba, 63, 92
Knossos style, 158
lamp
　Saturno, 29, 37, 133
　silk-voile, 29
　types, 28–35
lampshades
　fabrics for, 168
　shapes, 168, 171
　types, 29, 30, 33
Lee, Elsie Kruse McNeill, 140
Liberty-inspired patterns, 110
Murano beads, 80
nail-pleating, 104
Nast, Condé, 104
Negrin, Henriette, 30, 33, 181
Newton, Helmut, 41
nicknames, 123
opera, 37
Oriental gauze, 80
Othello costumes, 56, 57
paintings and drawings, 17, 20, 23
Palazzo Martinengo, 13–15, 15
Palazzo Pesaro-Orfei, 9
　after Fortuny's death, 139–140
　atmosphere, 29–30
　Henriette Fortuny at, 53
　location, 42
　restoration, 30
　rooms in, 13, 24, 37, 118
Paris society and Fortuny designs, 117
pâte-de-verre beading, 67–68, 95, 107, 114
patrons
　celebrity, 96, 99, 104, 113, 176, 178
　of Fortuny designs, 54
patterns, velvet, 139

MARIANO FORTUNY 187

photography, 42, 63
　autochrome, 83
　nude, 41, *41*
　paper, 54
　of Venice, 44
pigments for fabrics, 83
pleating machine invention, 113
pleats
　accordion style, 171
　Delphos dress, 95
　nail, 104
　patents for, 113
　permanant, 113
　process of, 171-172
　in silk, *58*, 95
political influence, 23
polychrome printing, 162-163
postwar period, 117
printing processes, 158-159, 162-163, 165, 166
Proust, Marcel
　admiration for Fortuny, 63-65, *139*
　Fortuny designs in novels, 63-64, *71*, 92
　impression of Fortuny, 9
　impression of Fortuny designs, 99, *107*
retail shop
　couture, 83
　Fortuny's first, 79
robes and coats, *72*
Sangiorgi, Giorgio, *151*

Schubert, Selma, 99
set designs for theater, *125*, 132-133
shawl
　Knossos style, *158*
　over-pleated Delphos dress, *96*
　silk-velvet, *80*
sheath, pleated silk-taffeta, *110*
signature garment, *176*
silk, 99
　lamp, voile, *29*
　pleated, *58*, 95
　printed velvets, *140*
　taffeta dresses, *110*
　velvet shawl, *80*
Società Anonima Fortuny, 65

stencils
　fabric, *53*
　Japanese *katagami* paper for, *114*
textiles
　antique, 144
　collections, 149
　designs, 79
　effects of light, 150
　Fortuny's first, 144
　historic collection, 144
　history, 149
　study of, 149-150
theater
　designs, 132-133
　introduction to, 123
　love of, 123
　Othello costumes, *56, 57*
　study of lighting, *125*, 129
theatrical furniture, *37*
velvet
　capes, *63*
　patterns, *139*
　printed, *153*
　printing processes, 166-167
Venice
　life in, 42
　photographs by Fortuny, 44
Welles, Orson, 57
work table, tiered, *30*

Editor, English-language edition: Eve Sinaiko
Design coordinator, English-language edition: Tina Thompson

Library of Congress Cataloging-in-Publication Data

Deschodt, Anne Marie.
　[Fortuny. English]
　Fortuny / Anne-Marie Deschodt, Doretta Davanzo Poli ; translated from the French by Anthony Roberts.
　　p. cm.
　Includes bibliographical references and index.
　ISBN 0-8109-1133-7 (hc)
　1. Fortuny, Mariano, 1871-1949. 2. Designers—Spain—Biography.
　I. Davanzo Poli, Doretta. II. Title.
　NK1535.F675 D4813 2001
　700'.92—dc21
　[B]　　　　　　　　　　　　　　　　　　　　　　2001022406

Copyright © 2000 Editions du Regard, Paris
English translation copyright © 2001 Harry N. Abrams, Inc.

Published in 2001 by Harry N. Abrams, Incorporated, New York
All rights reserved. No part of the contents of this book may be reproduced without the written permission of the publisher

Printed and bound in Spain

10 9 8 7 6 5 4 3 2 1

ABRAMS
Harry N. Abrams, Inc.
100 Fifth Avenue
New York, N.Y. 10011
www.abramsbooks.com

Photograph Credits

James Abbe: photograph of Natasha Rambova, 1924, page 95; Neil Dorr: photograph of Lillian Gish, page 96 left; courtesy the Metropolitan Museum of Art, New York, page 99; Museo Fortuny, Venice, page 151 top, page 170.

All of the textiles and garments belong to Liselotte Höhs unless otherwise indicated.

Text Credits

From *Rembrance of Things Past: Vol. 3* by Marcel Proust, translated by C. K. Scott Moncrieff, T. Kilmartin, & A. Mayor, copyright © 1981 by Random House, Inc. and Chatto & Windus. Used by permission Random House, Inc.; from *Eustace and Hilda* by L. P. Hartley, New York: Stein & Day, Publishers, 1947, courtesy The Society of Authors and the Literary Representative of the Estate of L. P. Hartley; from *The Group* by Mary McCarthy, New York: Harcourt. Brace, & World, Inc., 1954.

Acknowledgments

Thanks are due to Liselotte Höhs, in Venice, for her kindness in making available her remarkable collection of dresses and fabrics. The authors wish to thank many people and institutions for their kind assistance: in London, Madeleine Ginsburg and Valerie D. Mendes, Curators in the fabrics department, Victoria & Albert Museum; Alexander Schouvaloff, Curator of the Theatre Museum branch, Victoria & Albert Museum; Mr. and Mrs. Chow and Meriel McCooey; in New York, Paul Ettesvold, Curator, the Costume Institute, Metropolitan Museum of Art; Washburn Gallery; Bill Cunningham; in Venice, Timothy and Isabelle Hennessy; Guido Perocco, Curator, Galleria d'Arte Moderna; Sandro Mescola, Curator, Museo Fortuny; Paolo Peruzza of the Assessorato ai Beni Artistici e Culturali; the French Consul in Venice; Marina Mondino; Mr. and Mrs. Curtis, owners of Palazzo Barbaro; M le Duc et Mme la Duchesse Decazes, owners of Palazzo Polignac; Alvise Chiggiato, former administrator of Mariano Fortuny's Giudecca factory; Alfredo Todisco; Mr. Provasoli; in France, Helmut Newton; Eric Deschodt; Yvonne Deslandres, Curator of the Musée Historique des Tissus, Lyon; Jacky Brézillon; M. Jean-Gabriel Vial, Professor, Ecole des Industries Textiles, Lyon; Mme Boucher; Jacques de Bascher; Jean Le Puil; Philippe Girard; Eric Peaudecerf; the staffs of the Fonds Formey, Bibliothèque de l'Arsenal, and Bibliothèque-Musée de l'Opera, Paris.